Break The Cycle

An adult coloring book of mandalas, filigree, and geometric patterns.

by Tim Pangburn

Copyright © 2016 by Tim Pangburn

All rights reserved. No part of this publication may be reproduced, distributed, or transmitted in any form or by any means, including photocopying, recording, or other electronic or mechanical methods, without the prior written permission of the publisher.

Printed in the United States of America
First Printing, 2016

ISBN-13: 978-1535283618
ISBN-10: 1535283610

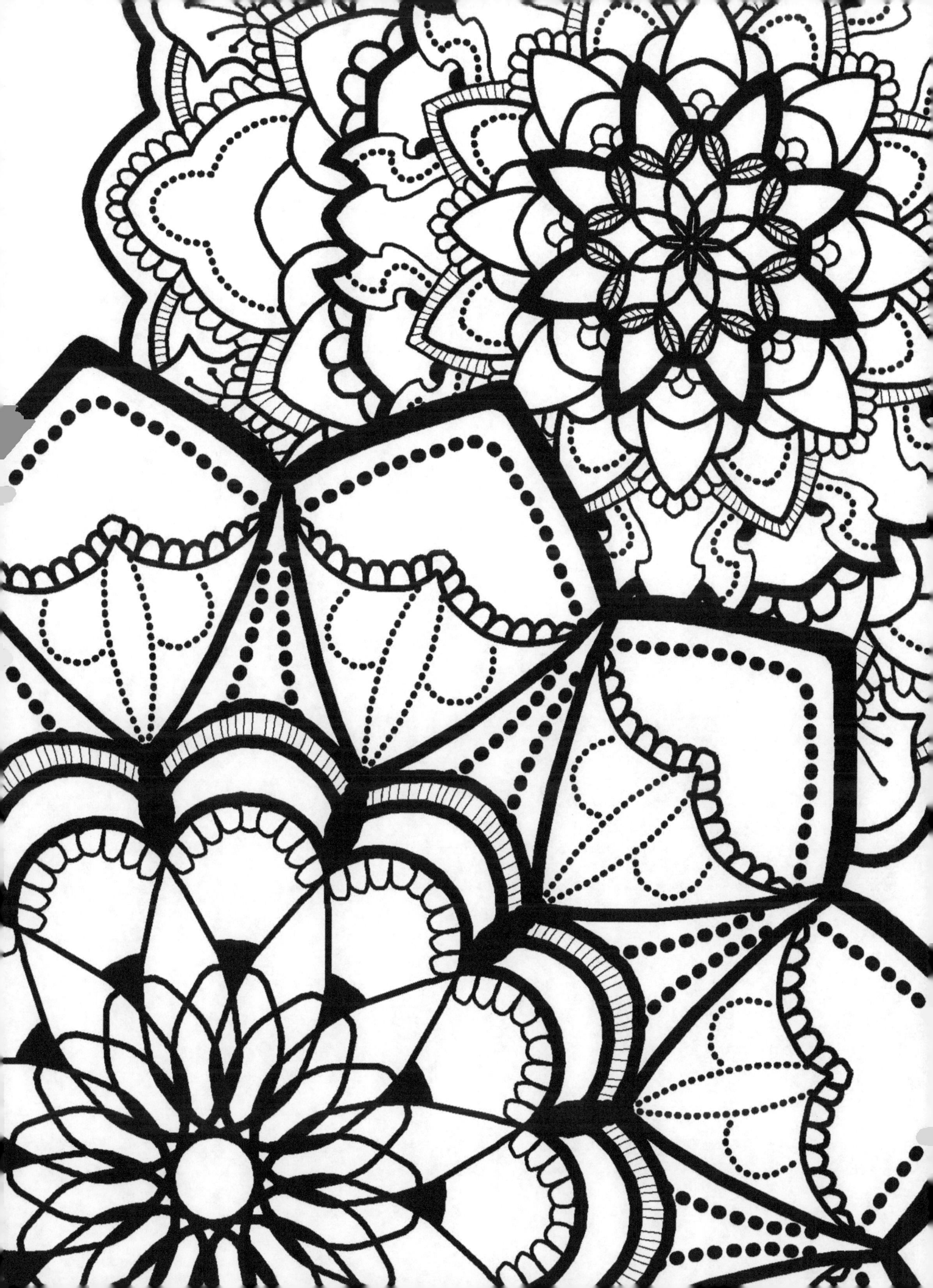

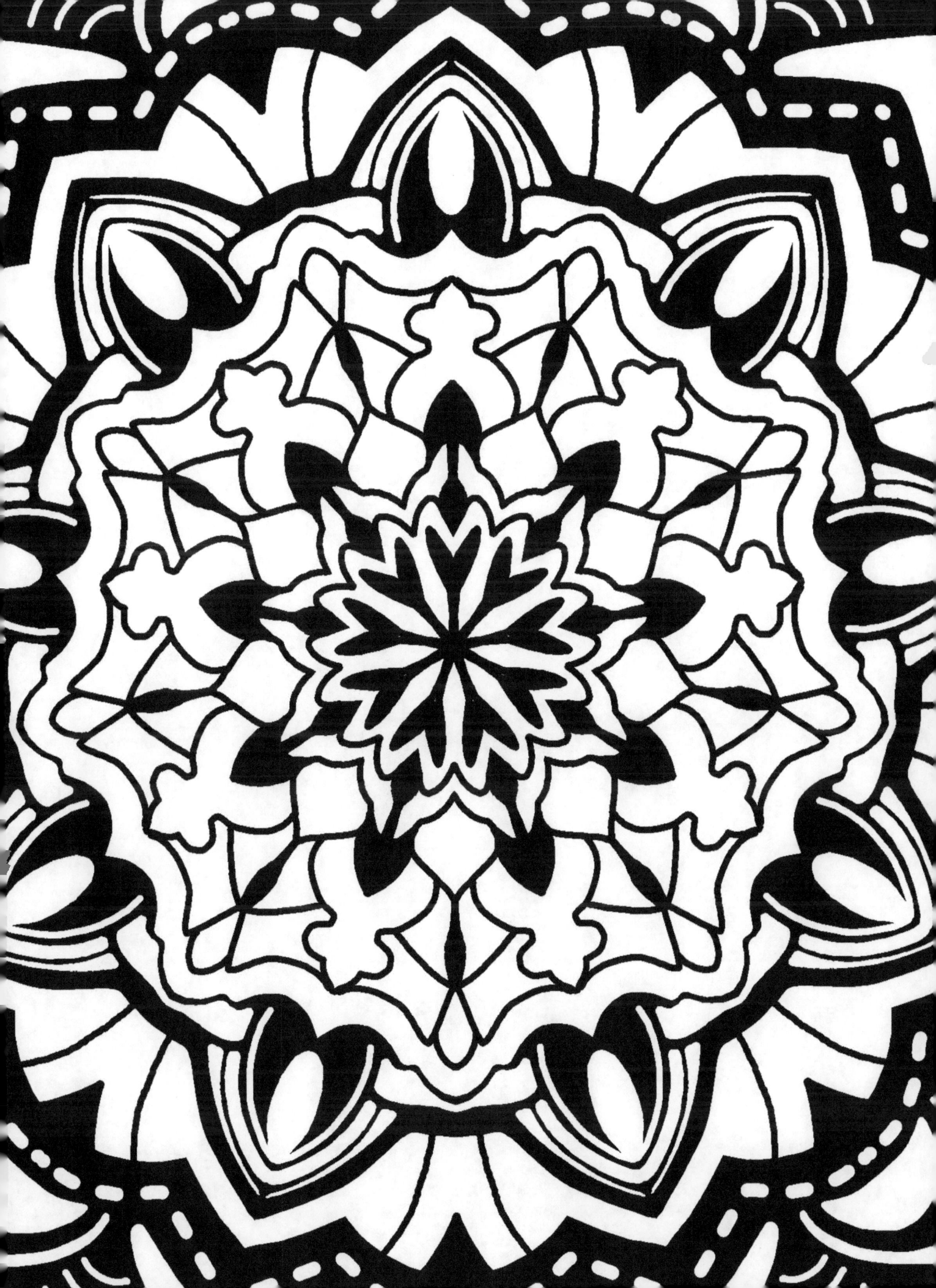

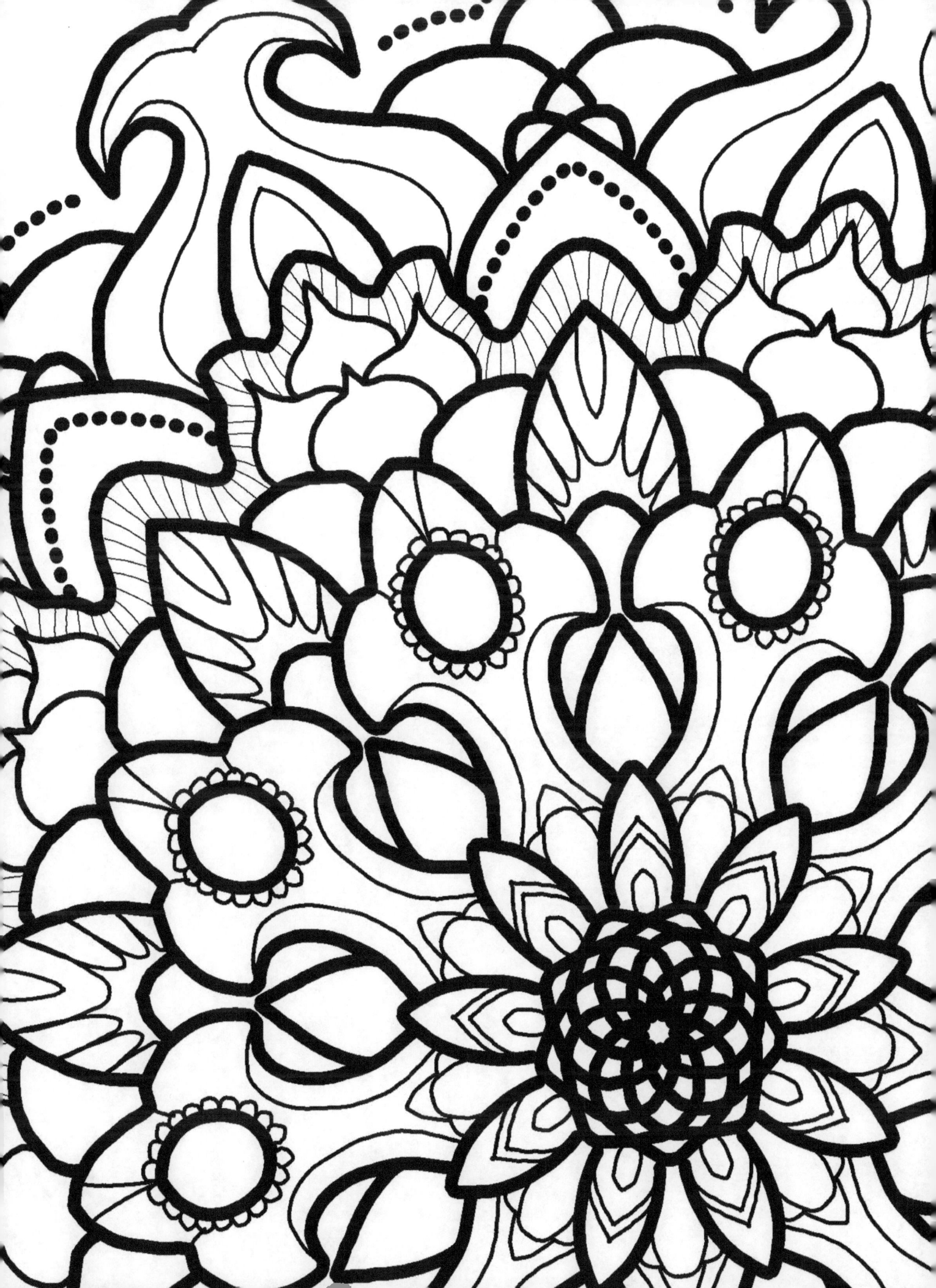

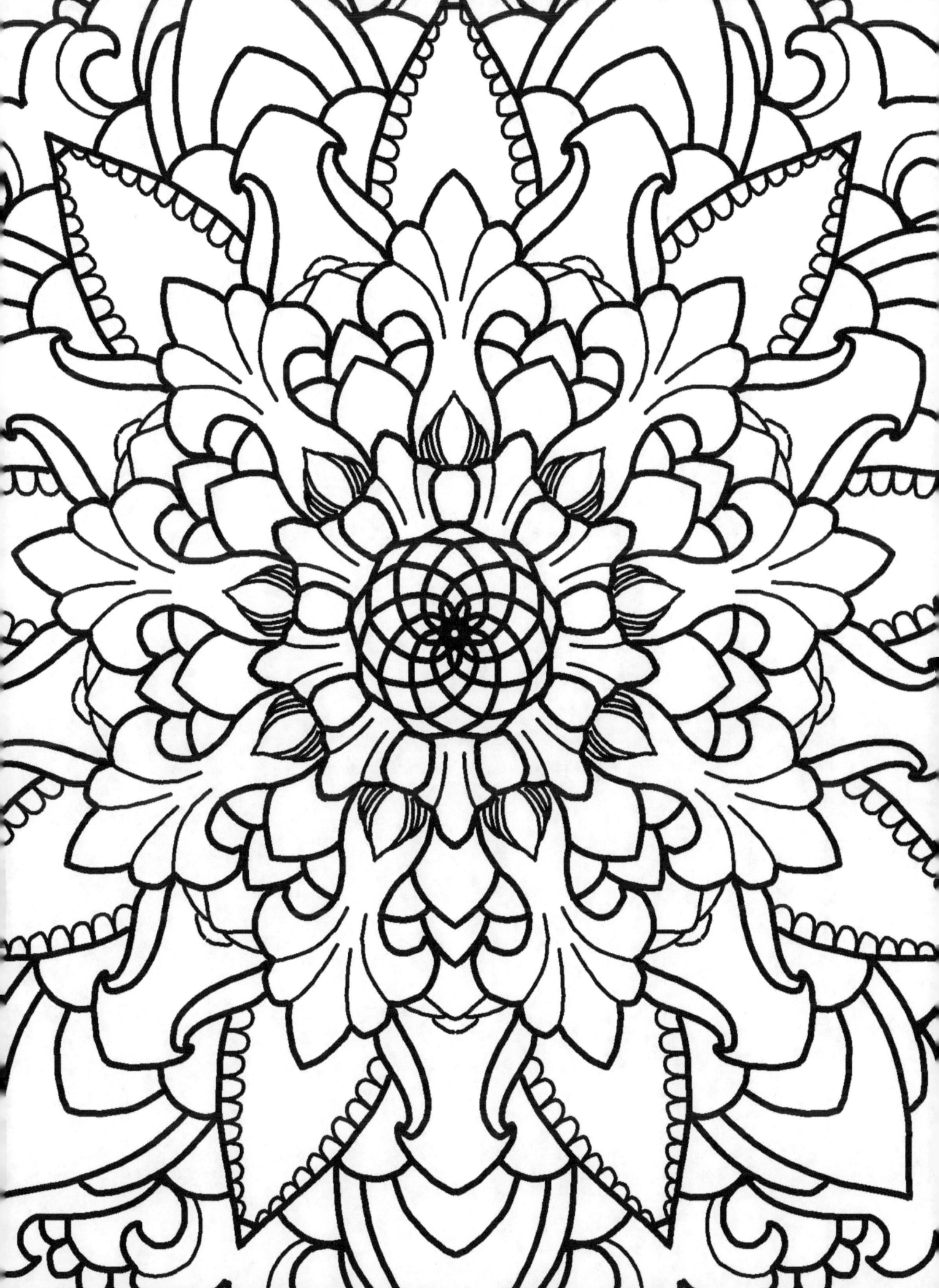

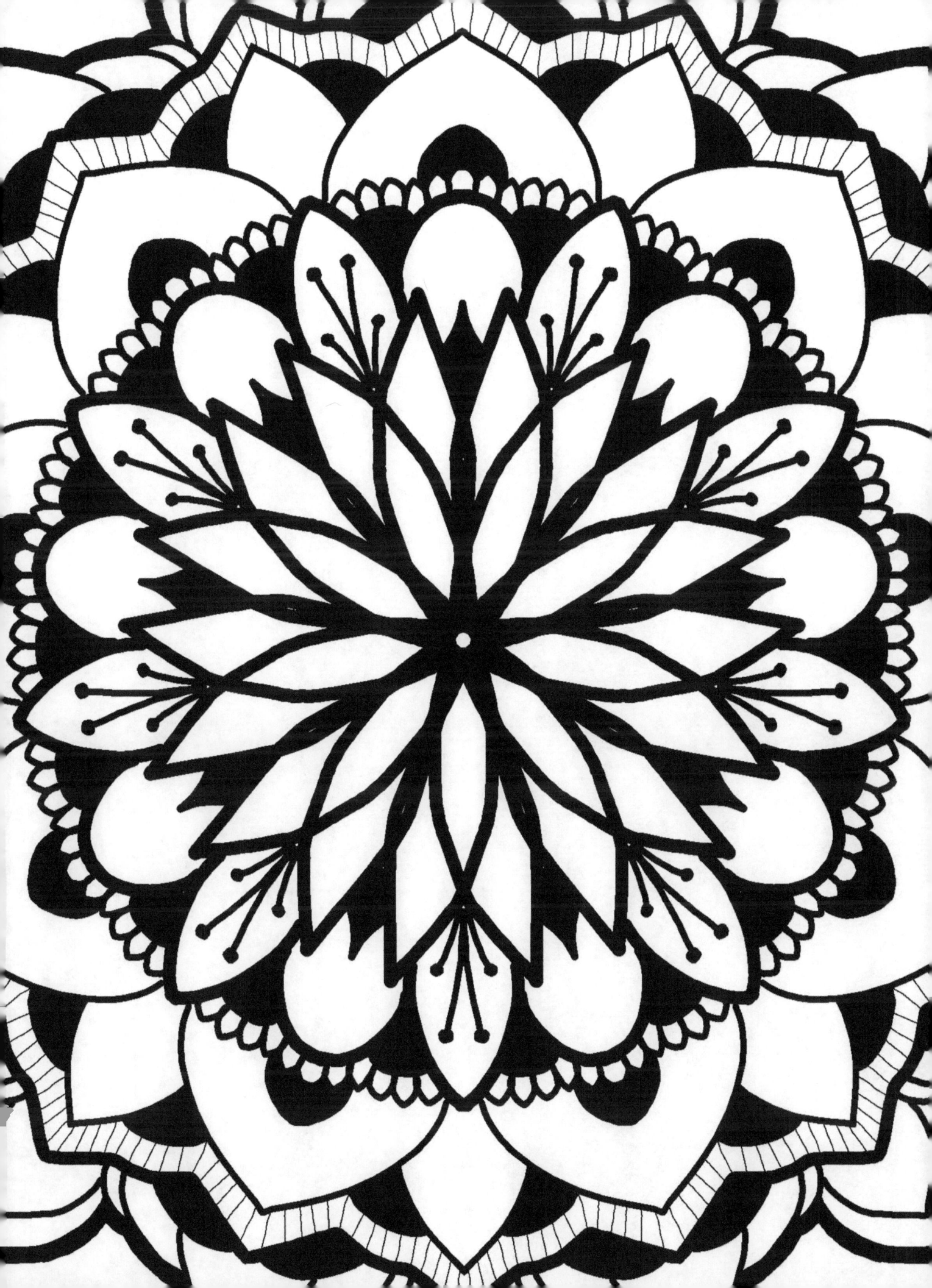

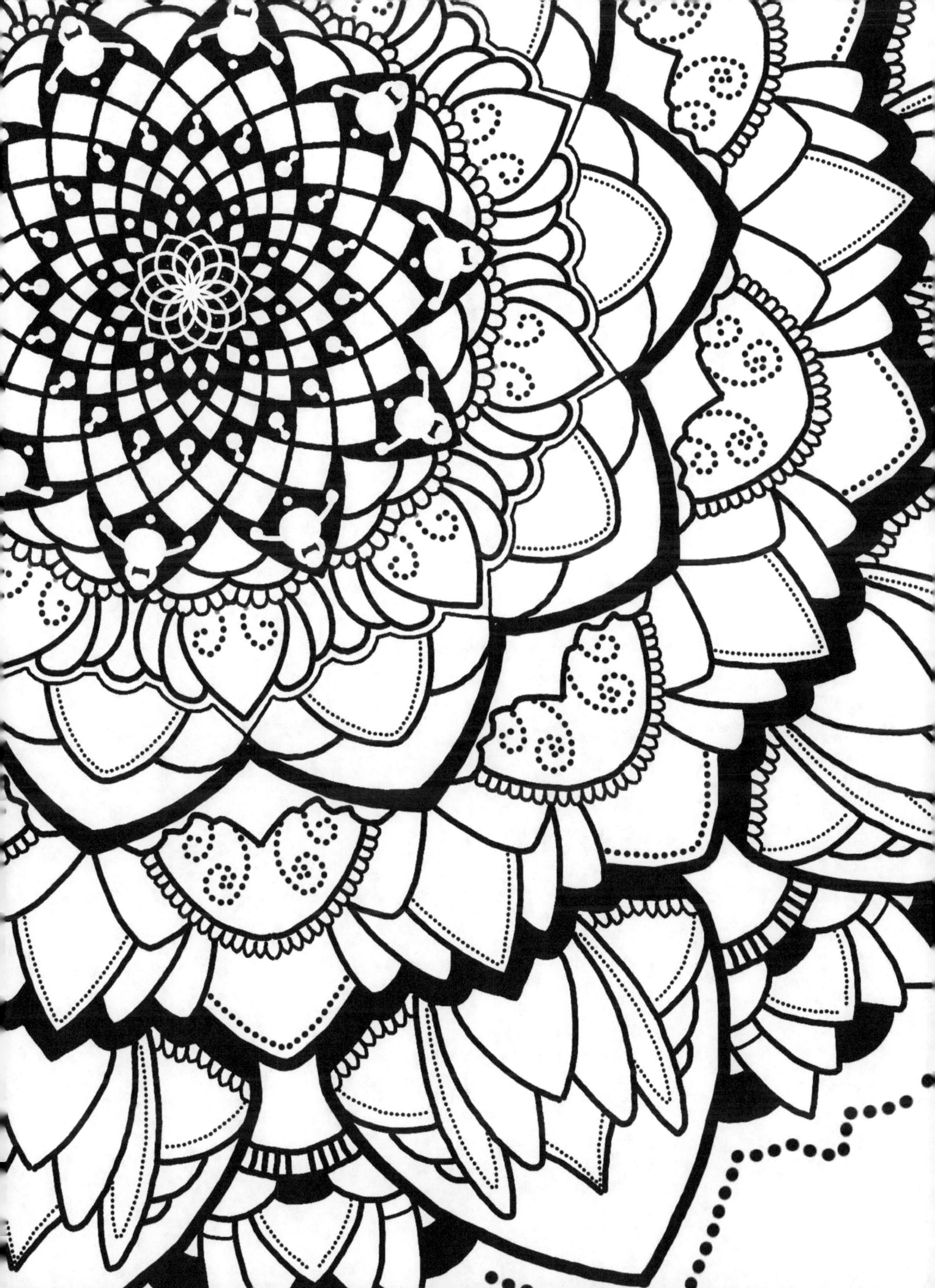

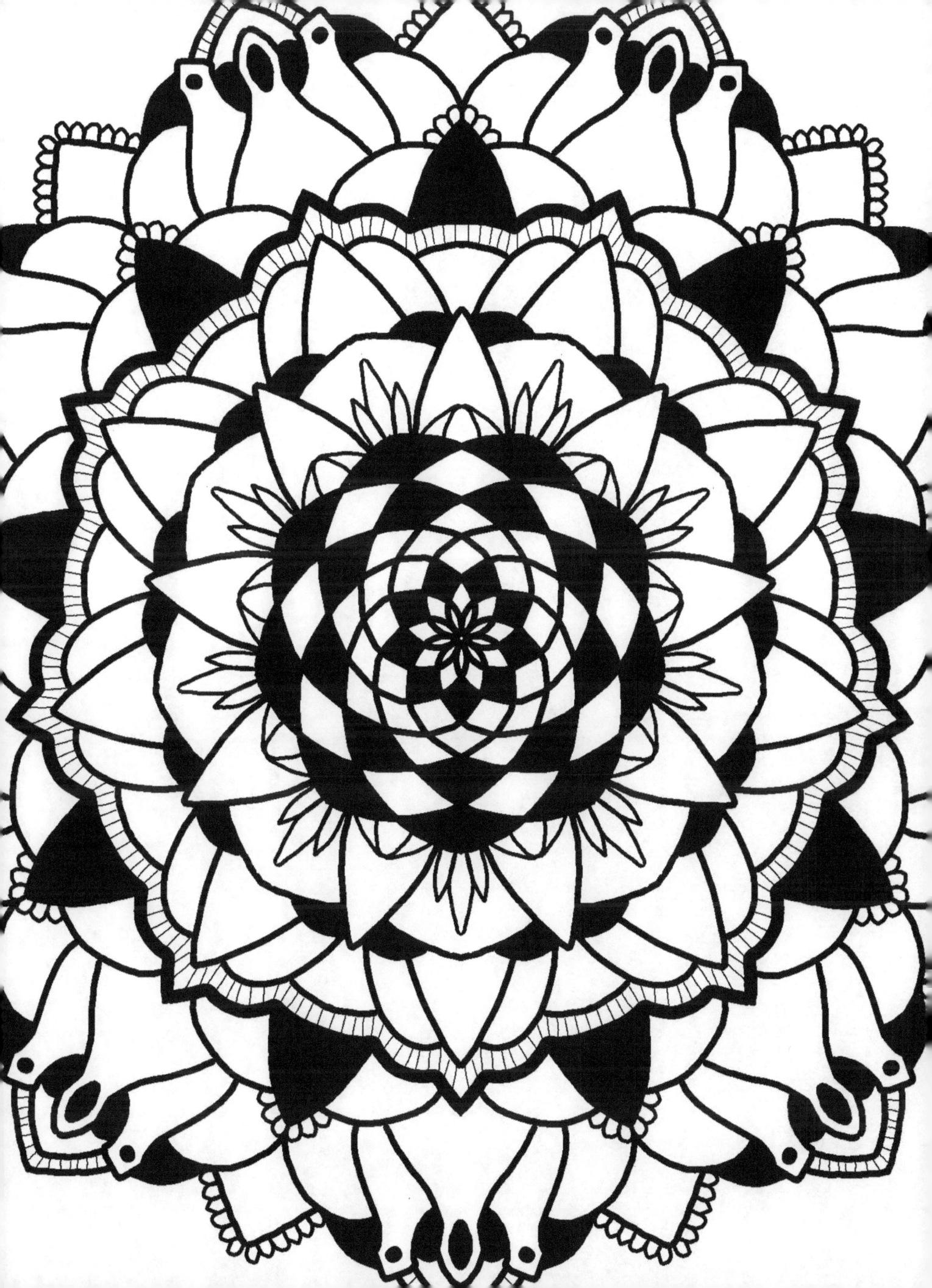

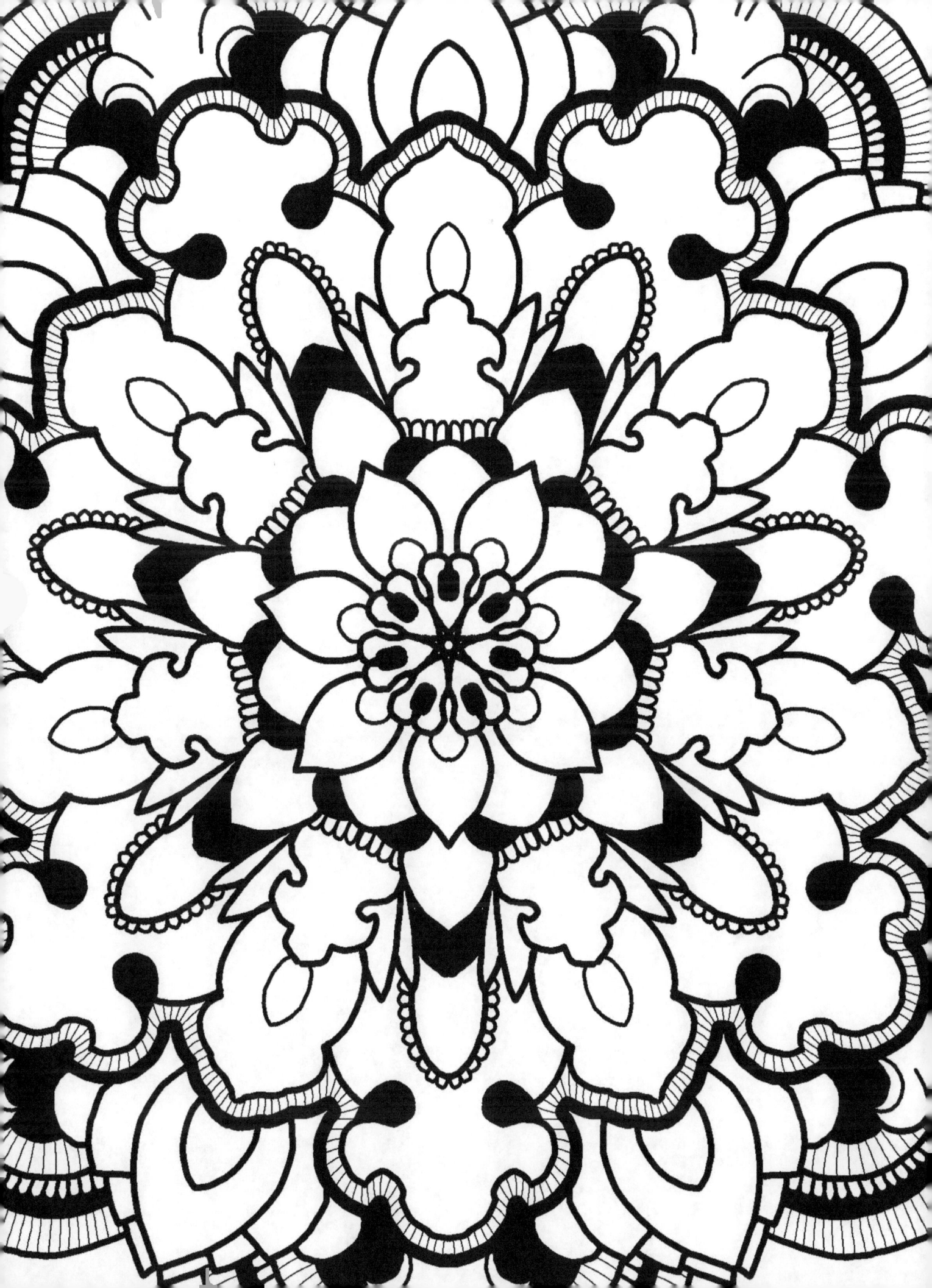

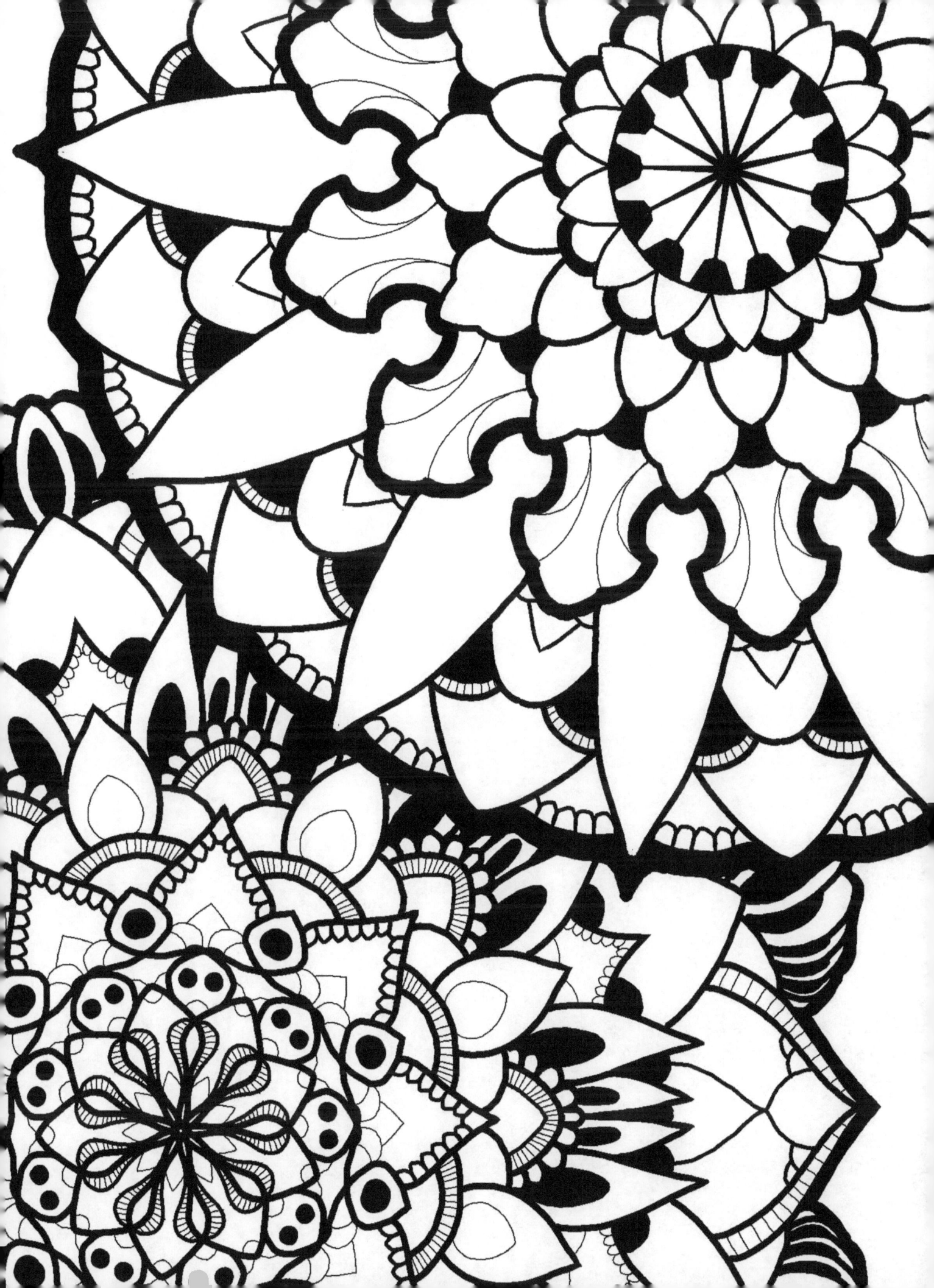

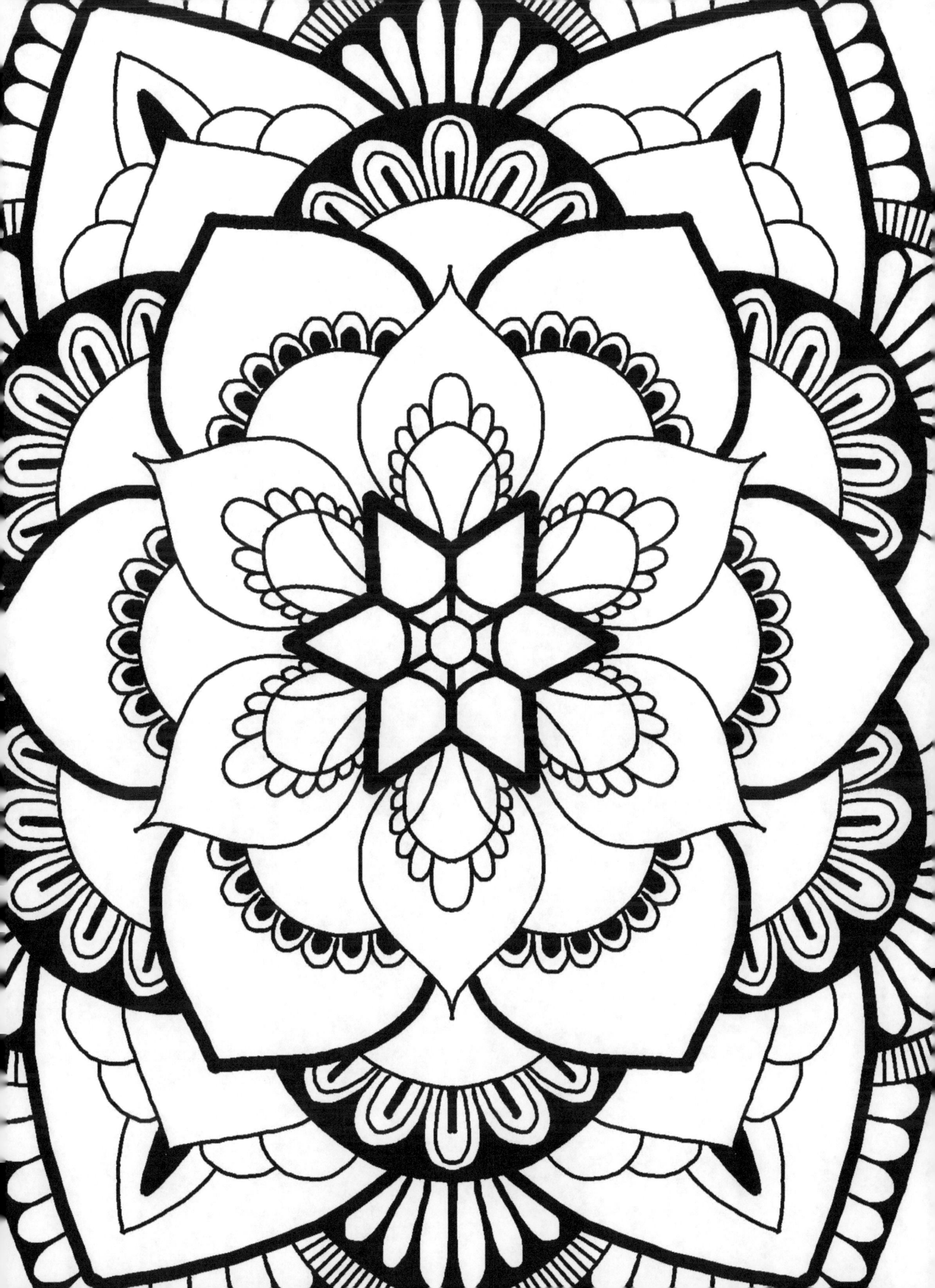

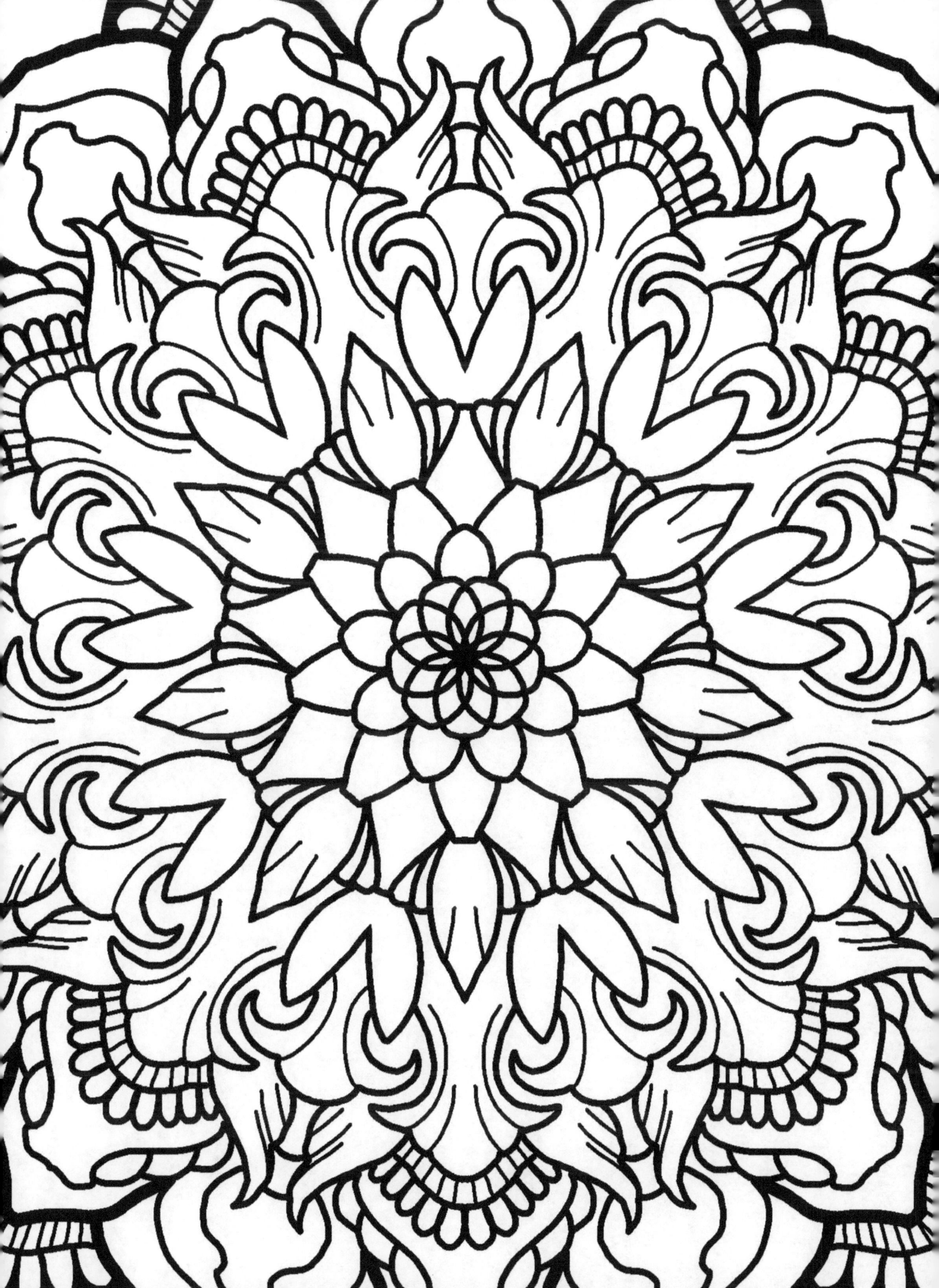

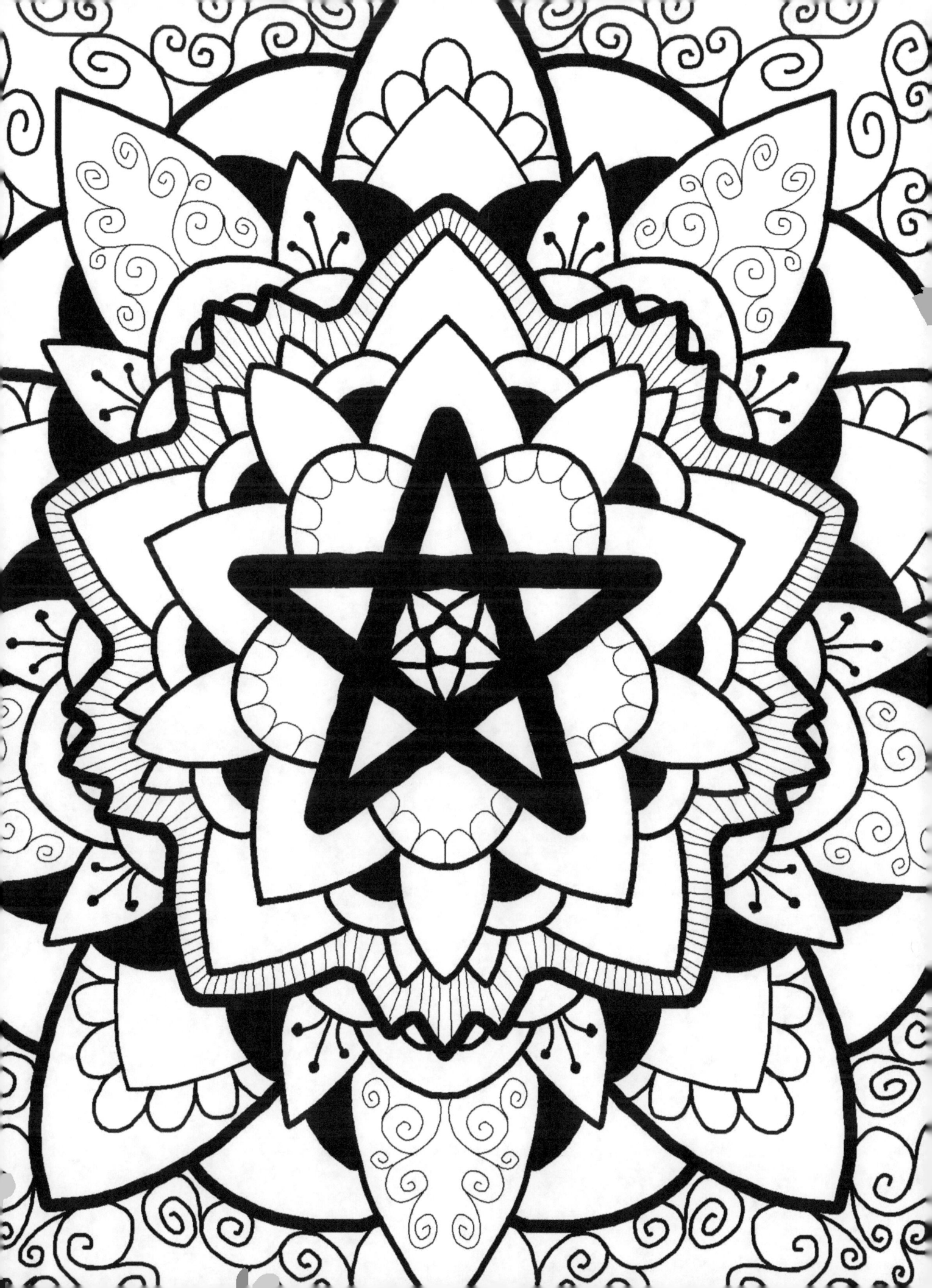

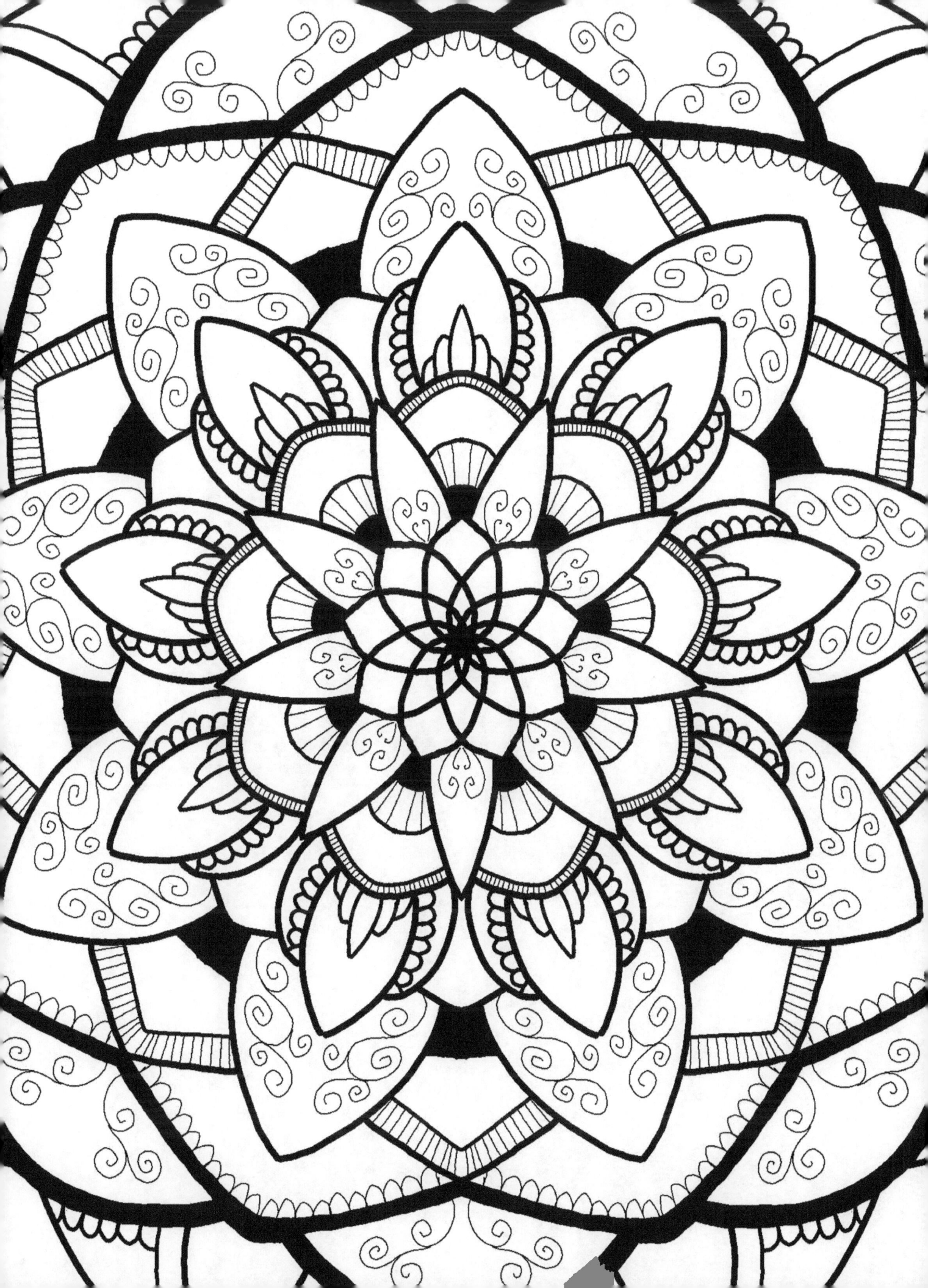

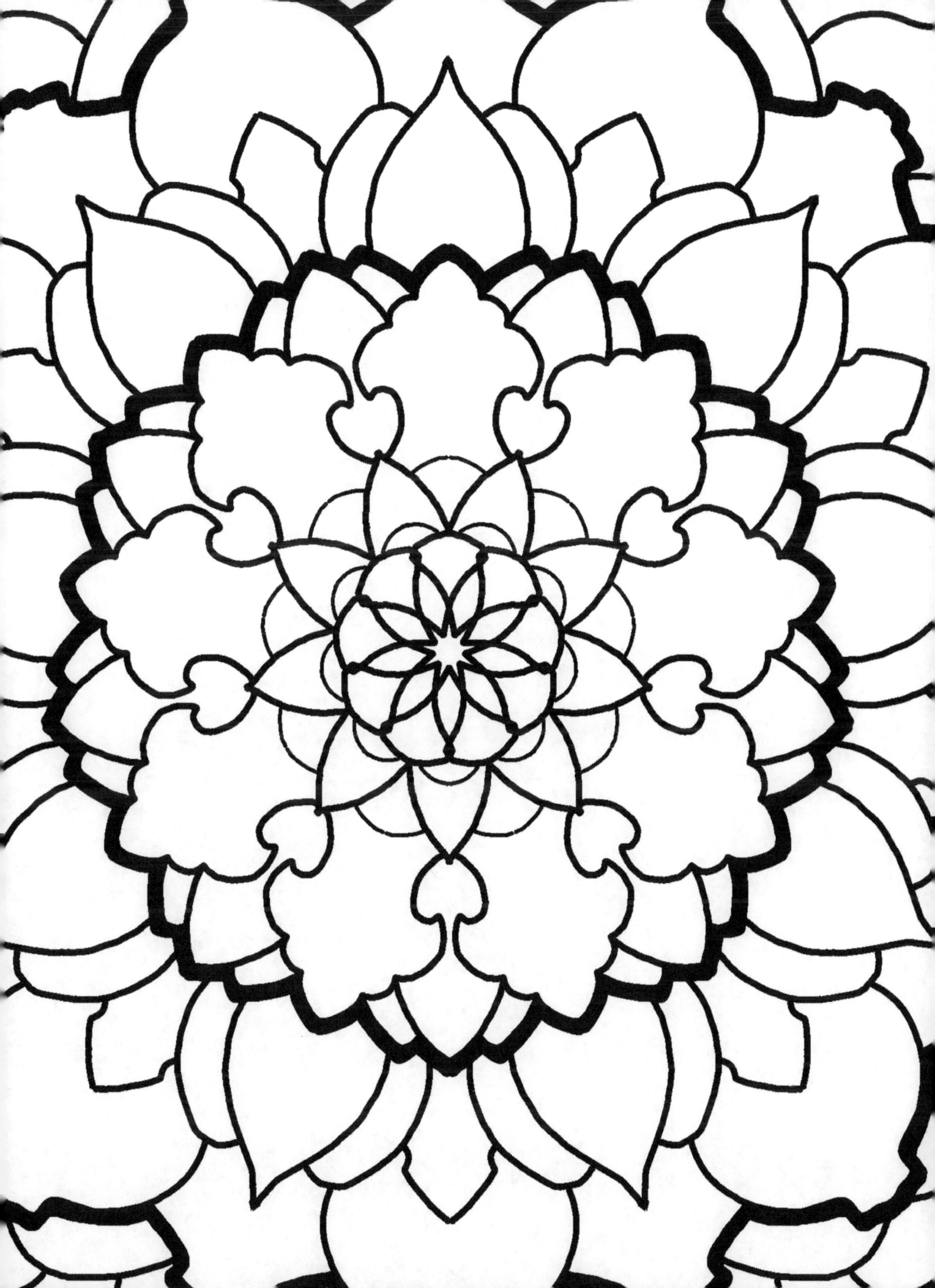

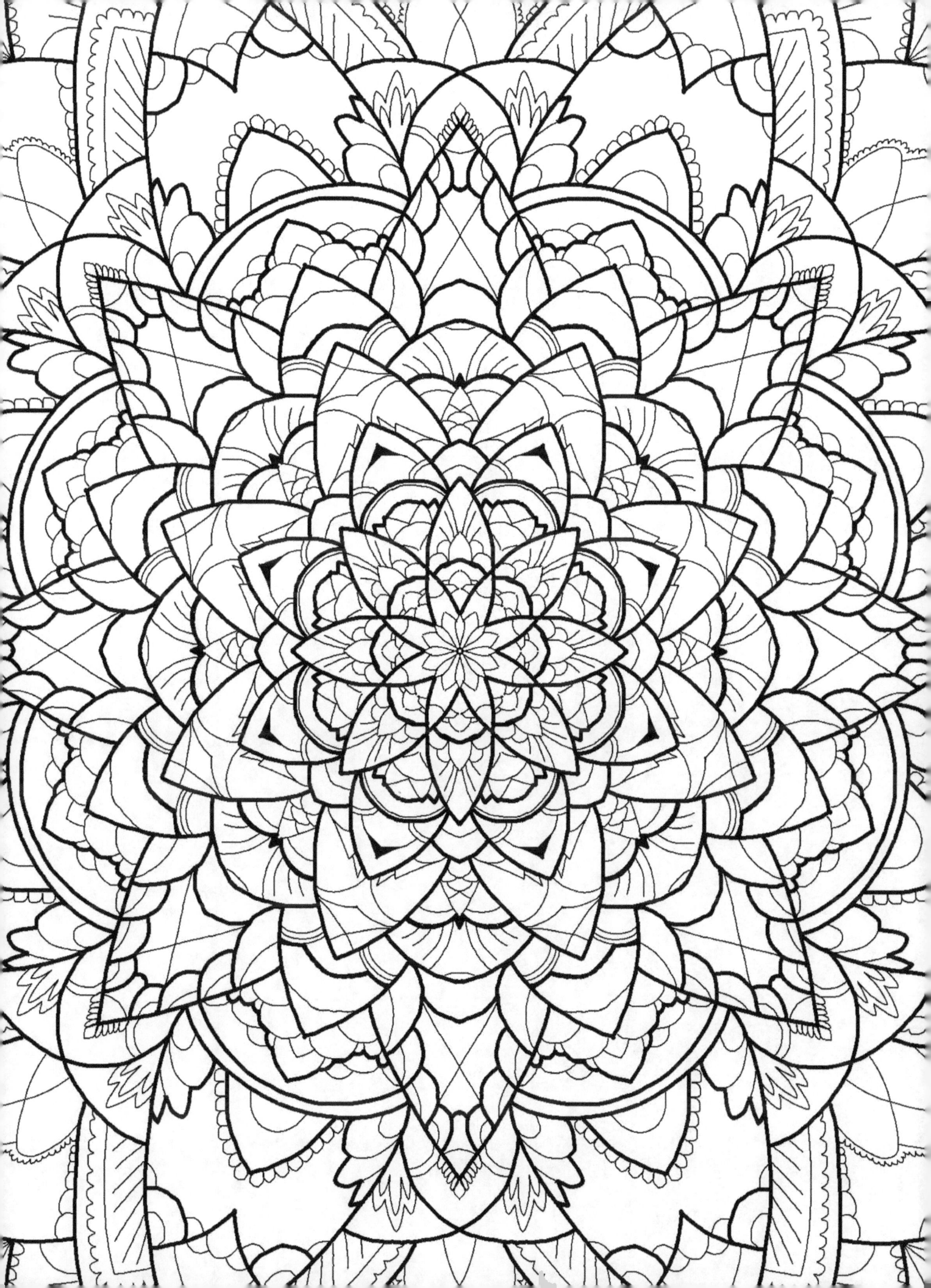

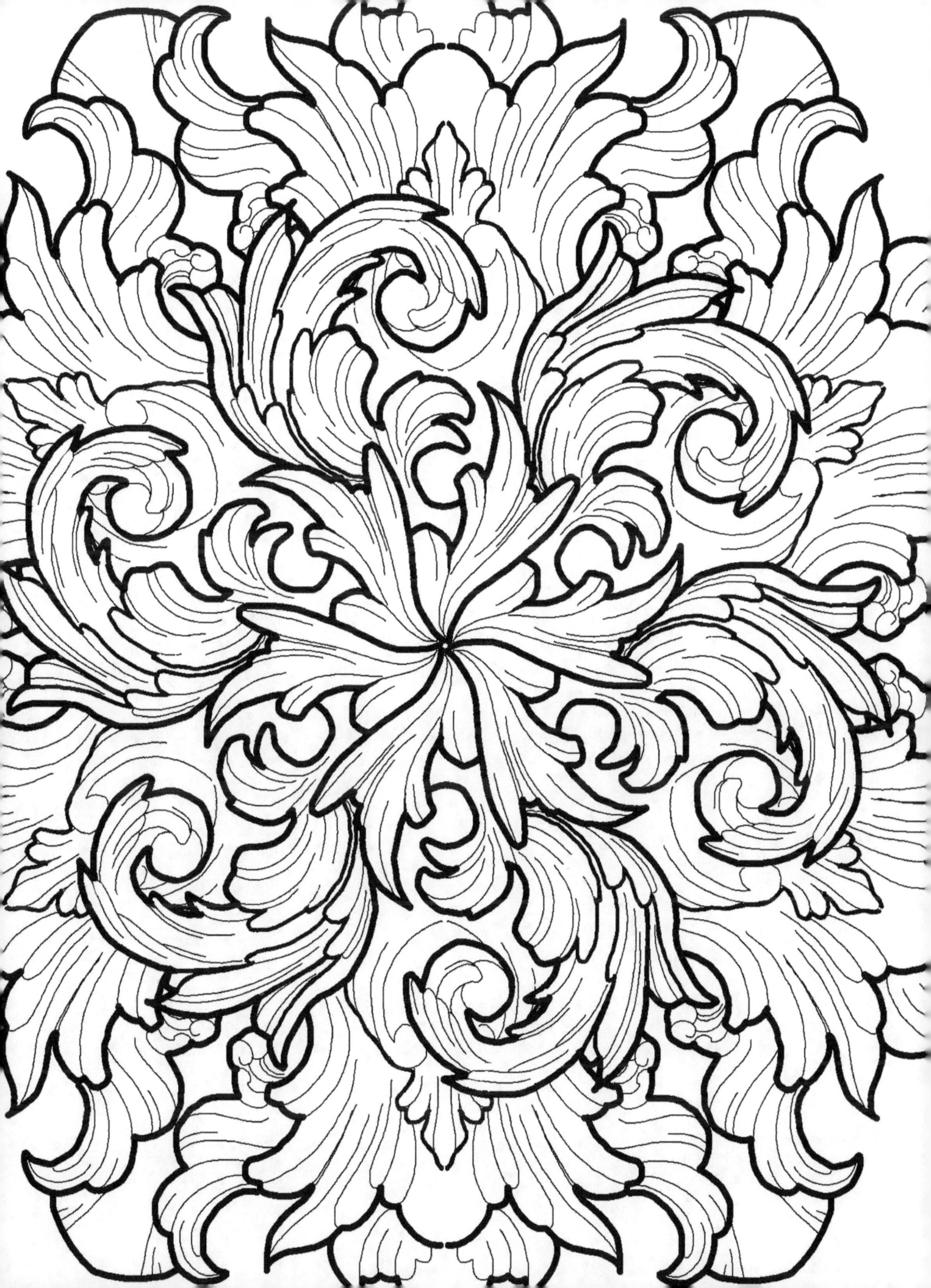

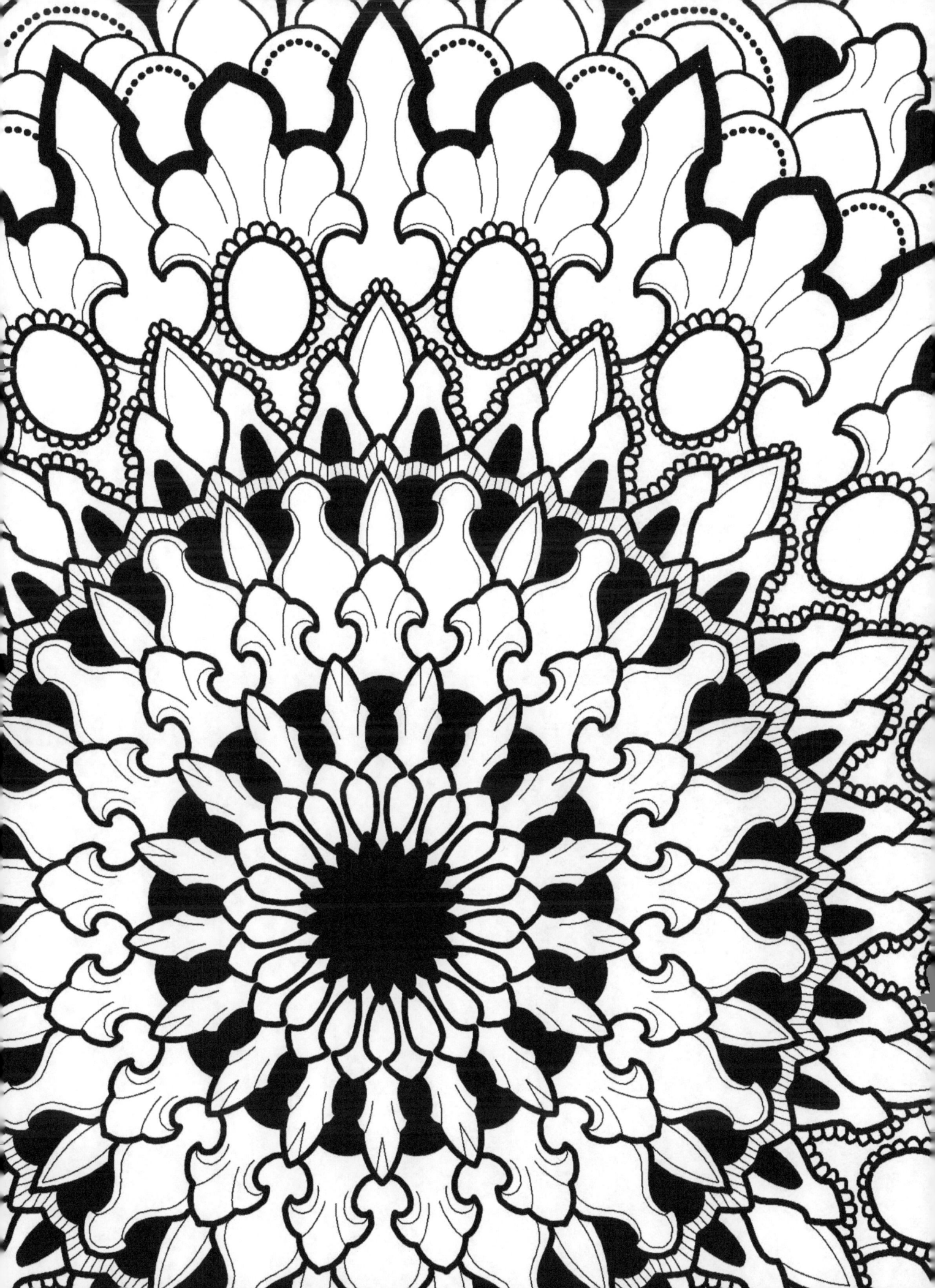

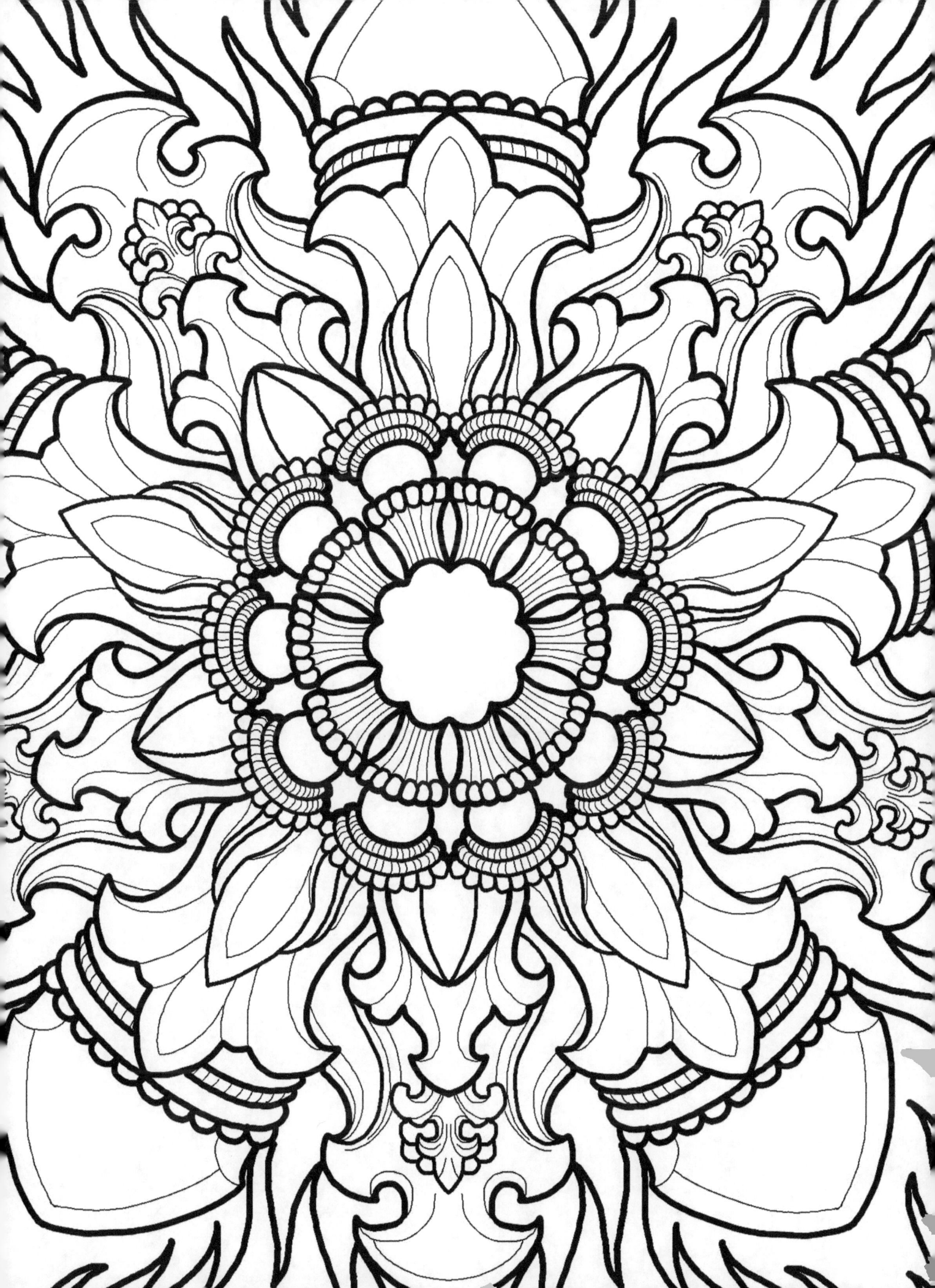

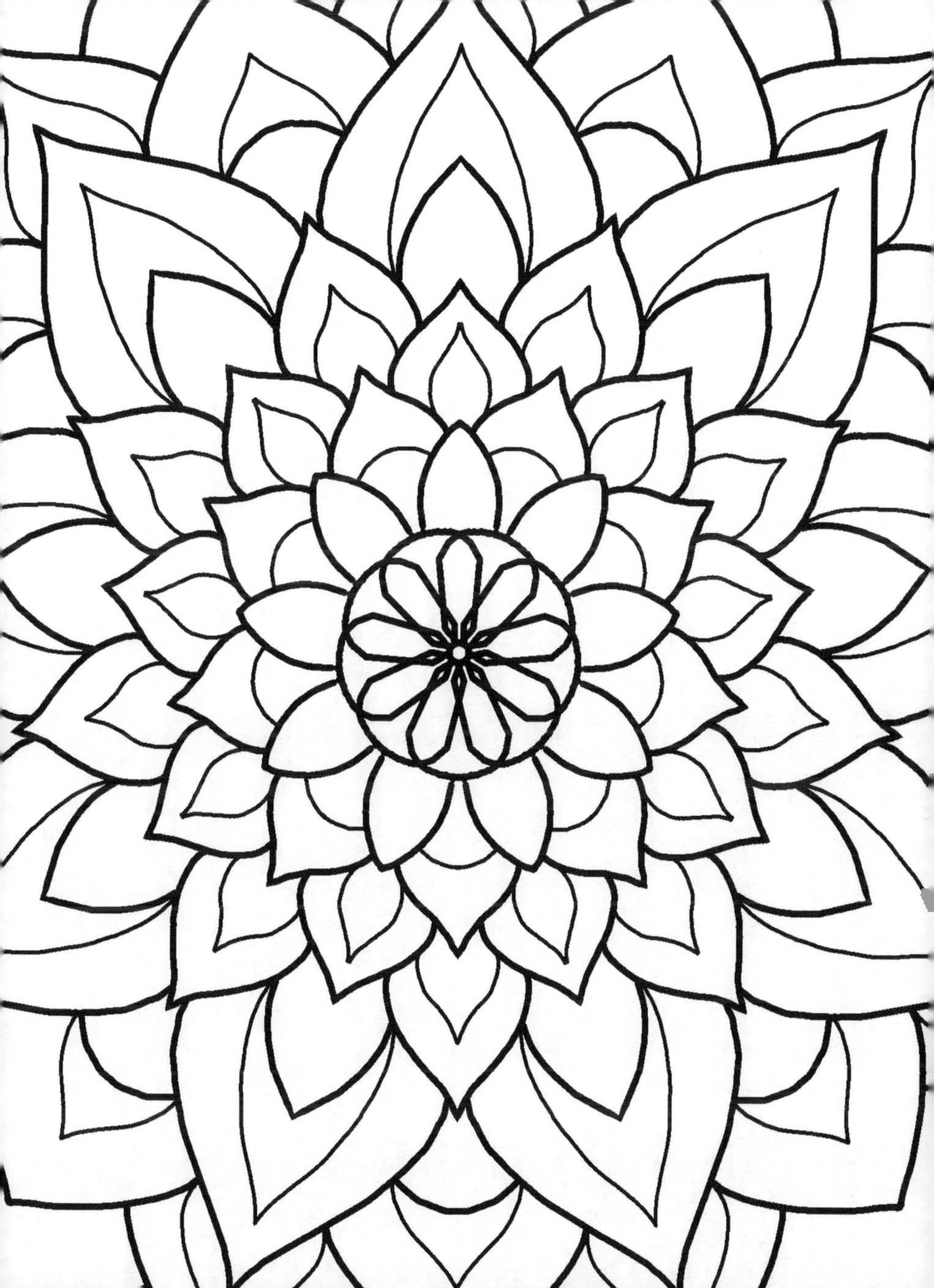

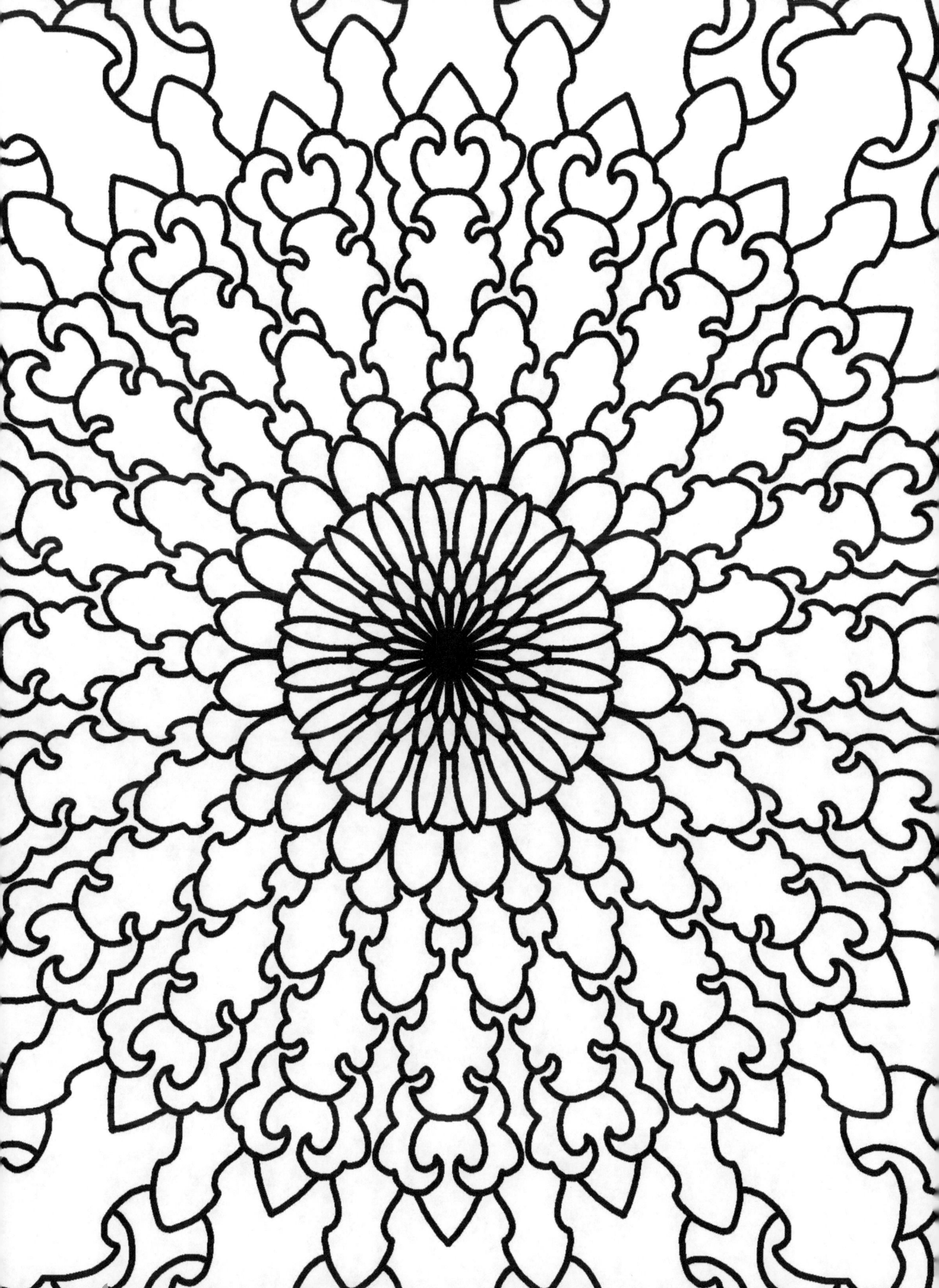

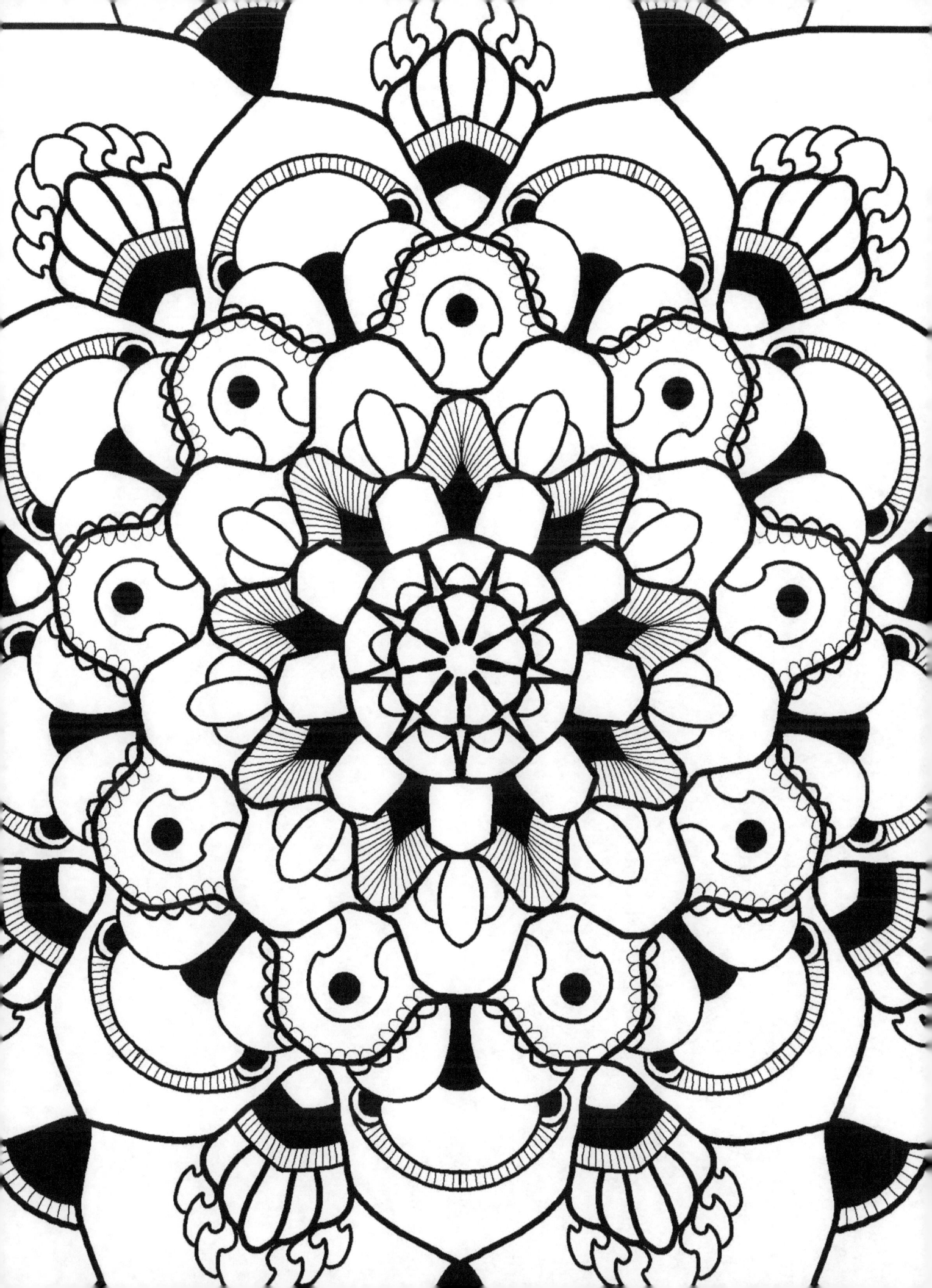

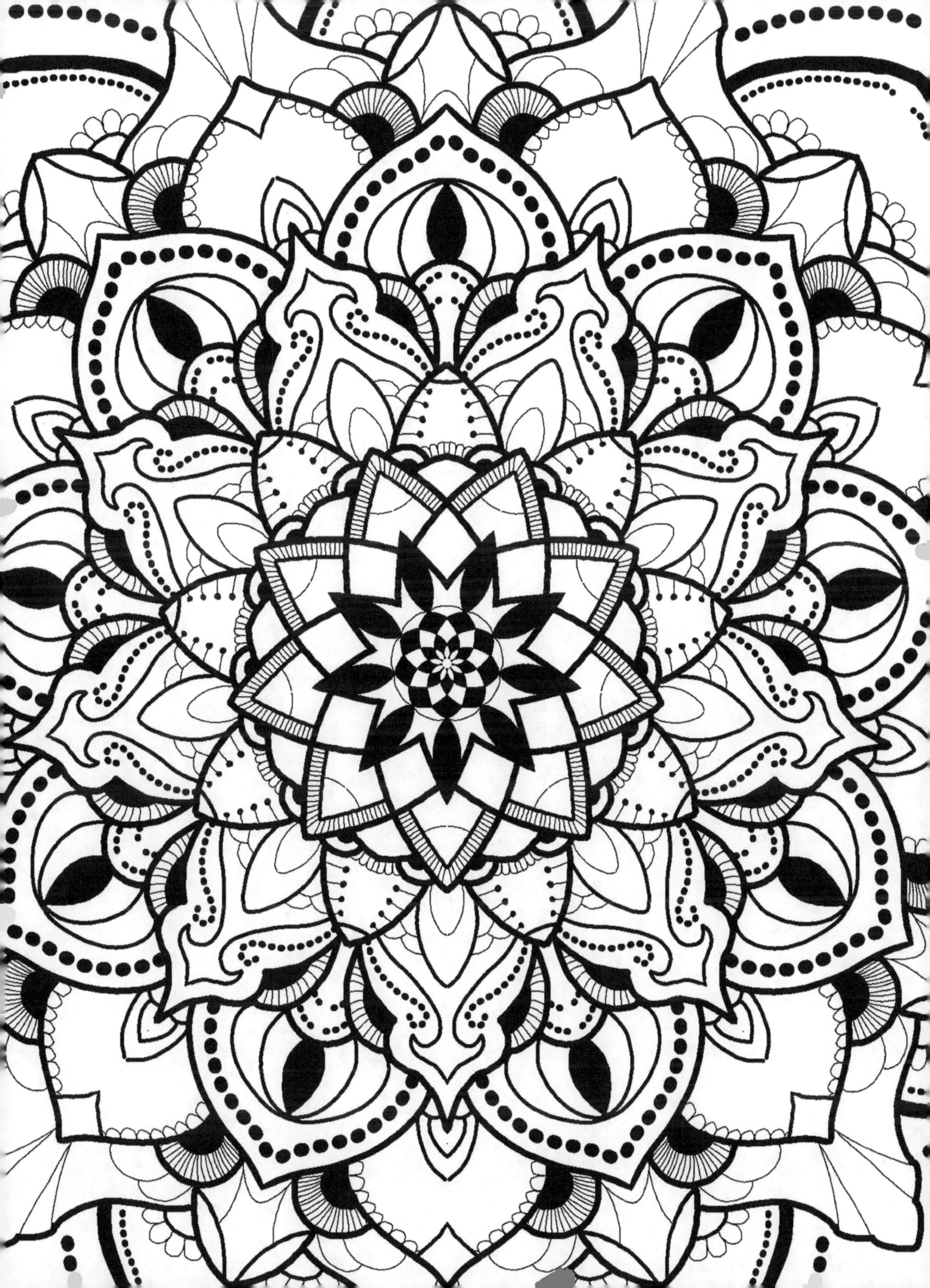

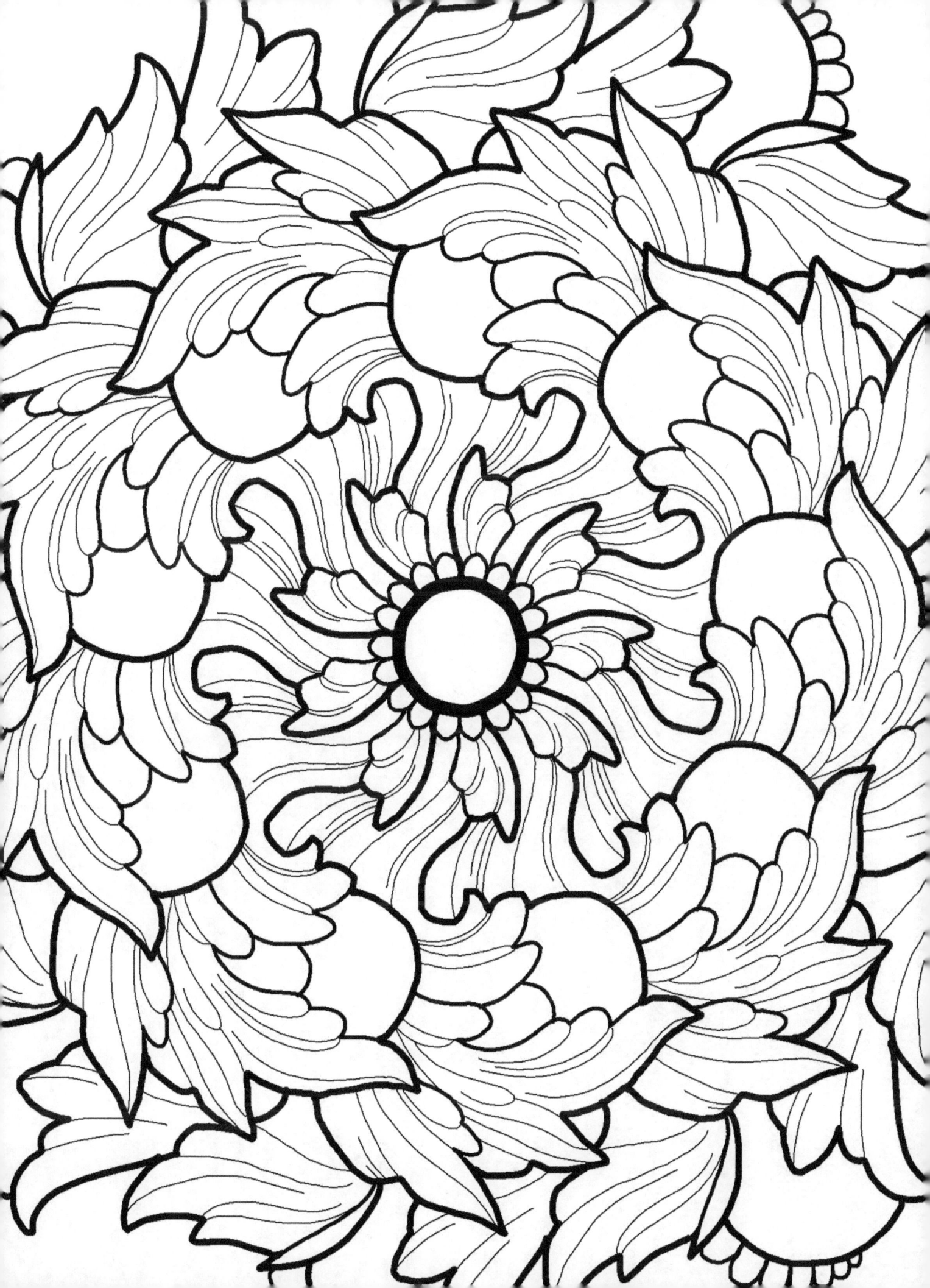

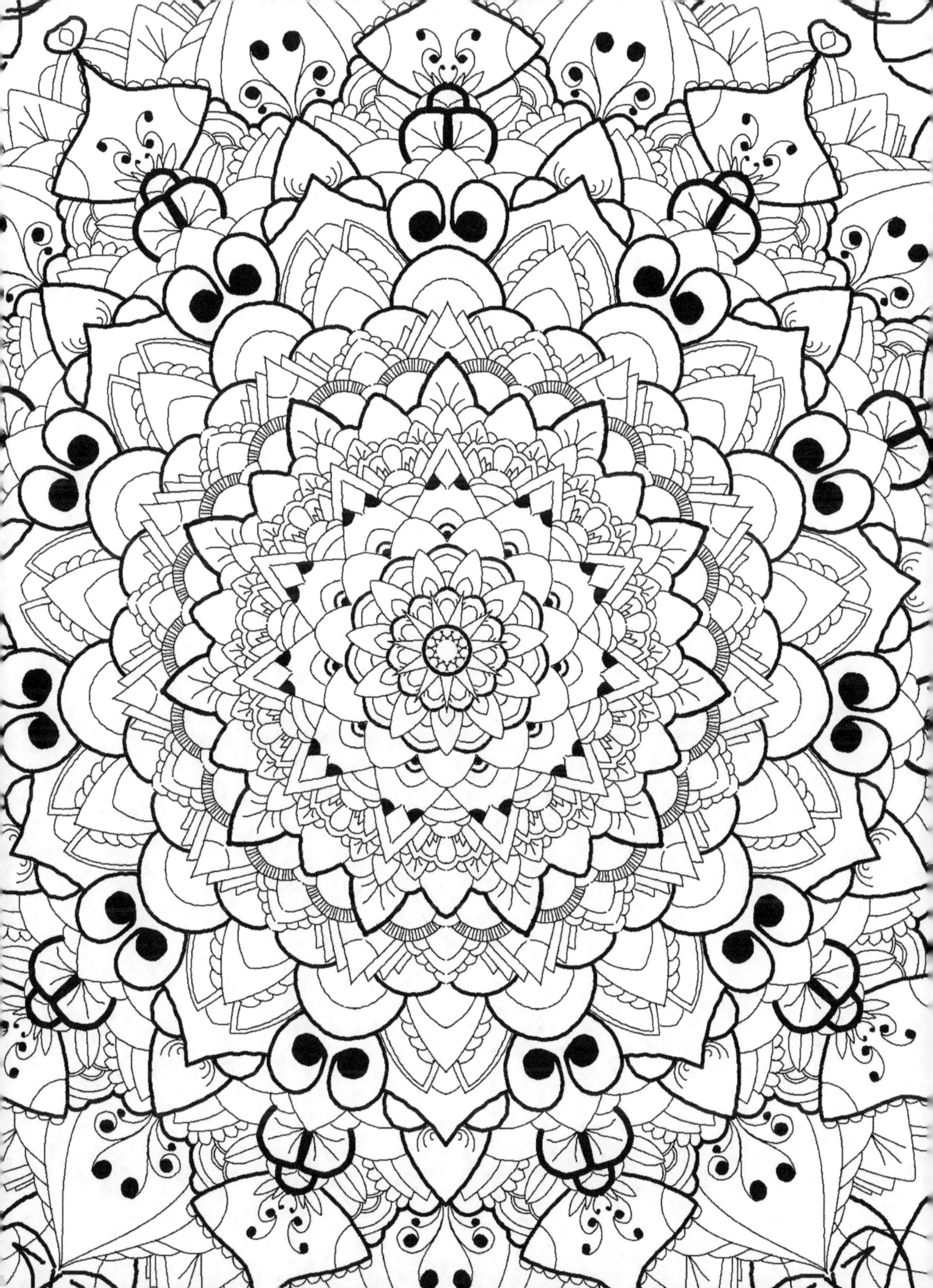

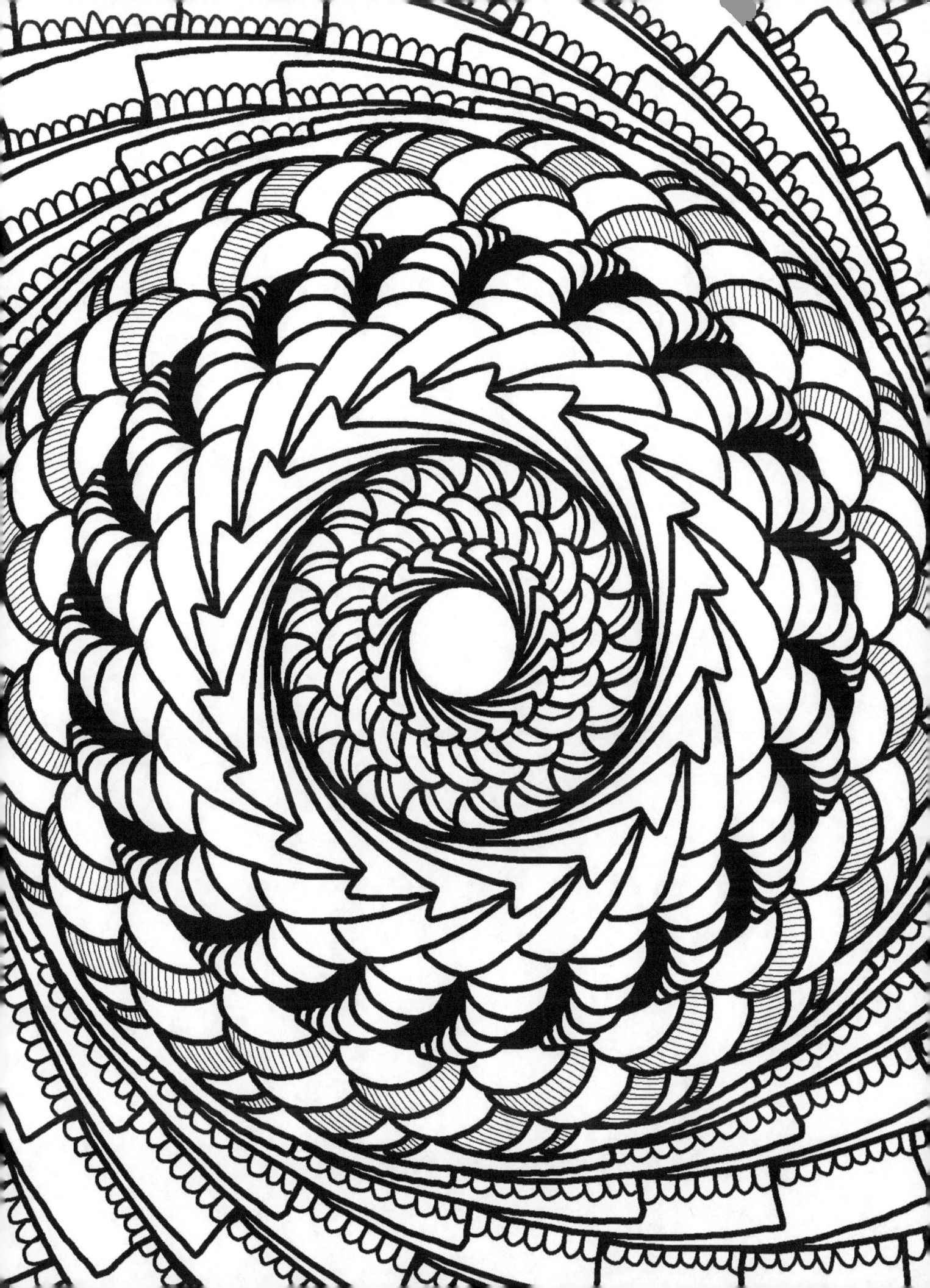

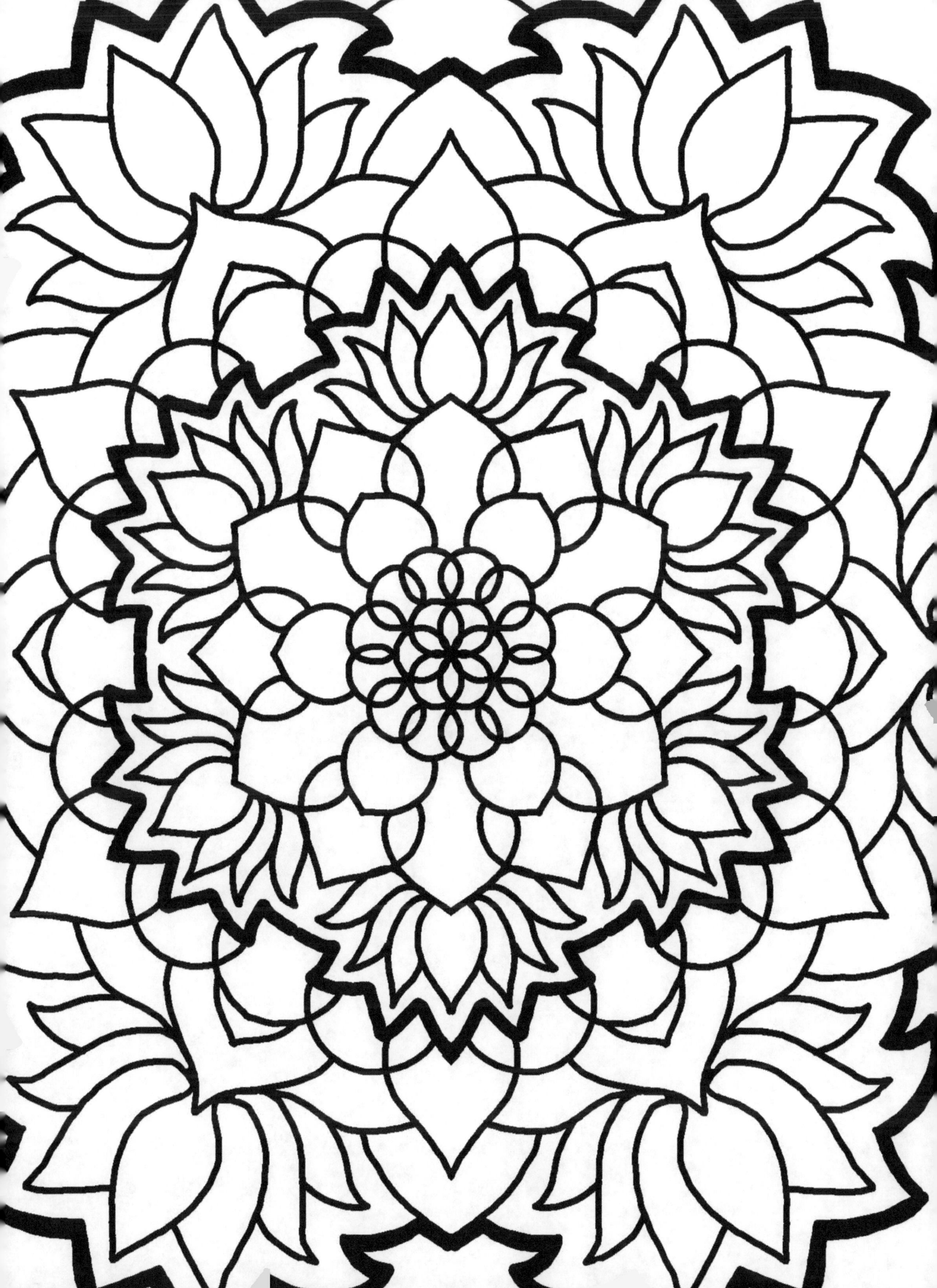

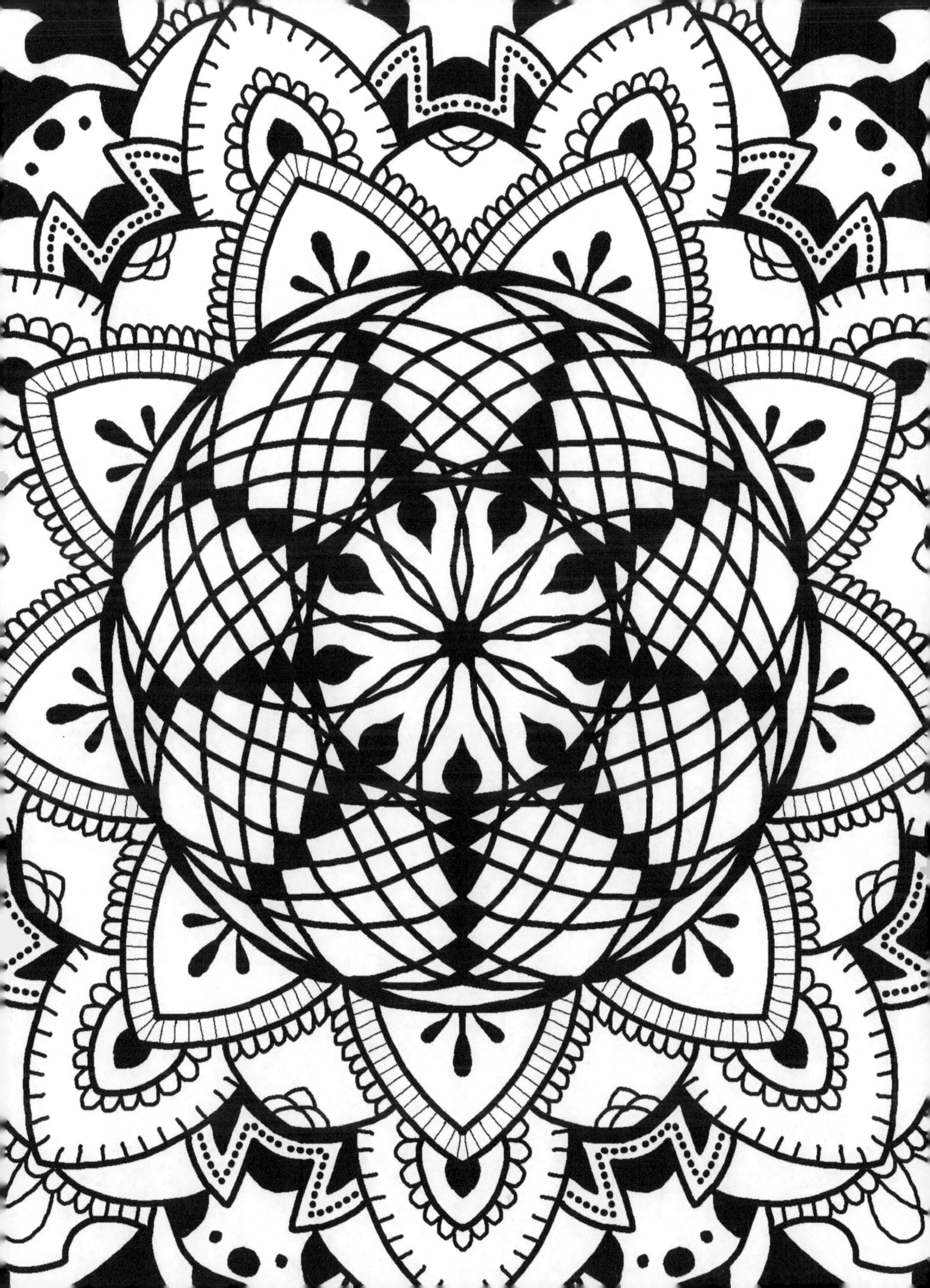

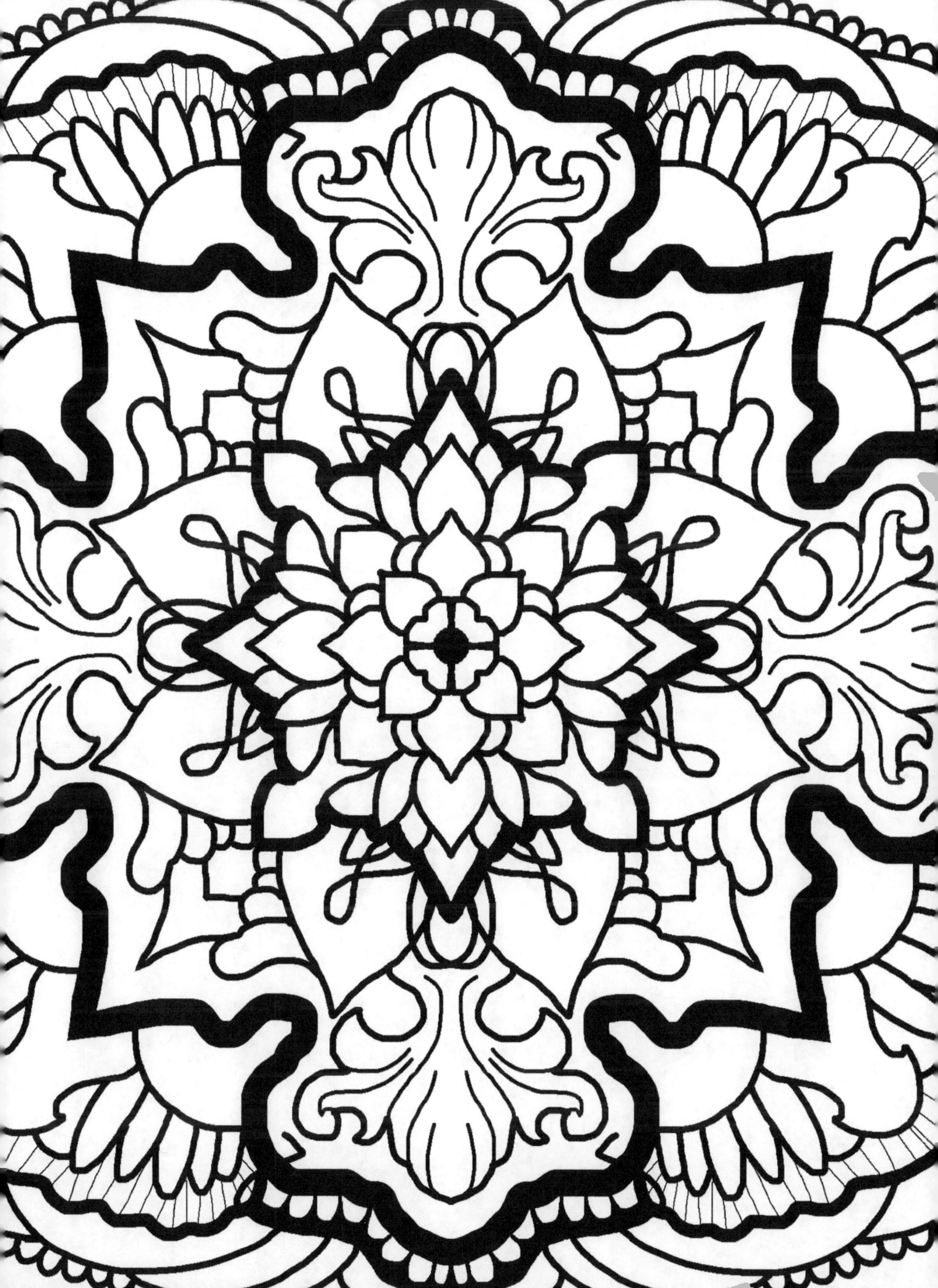

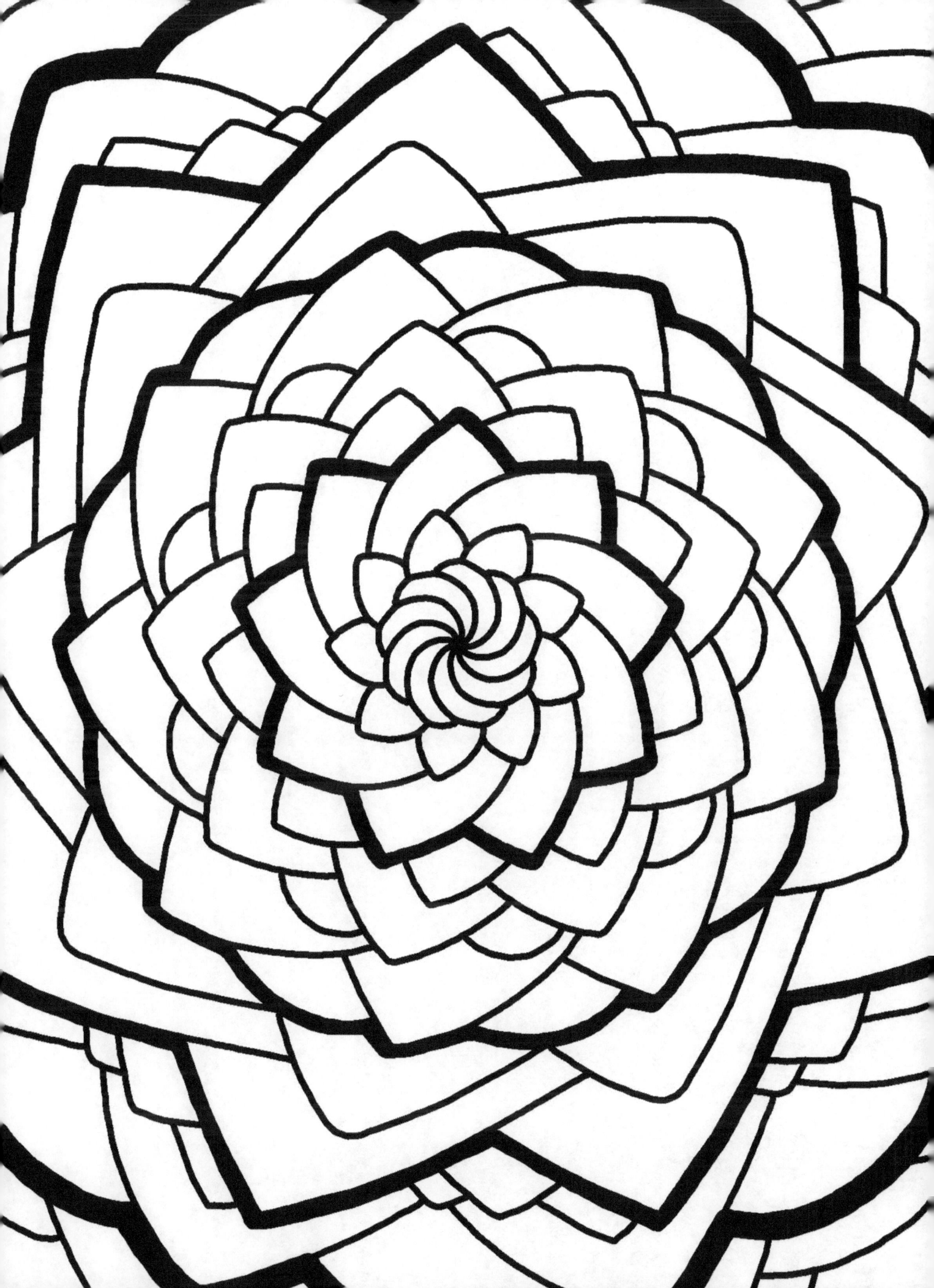

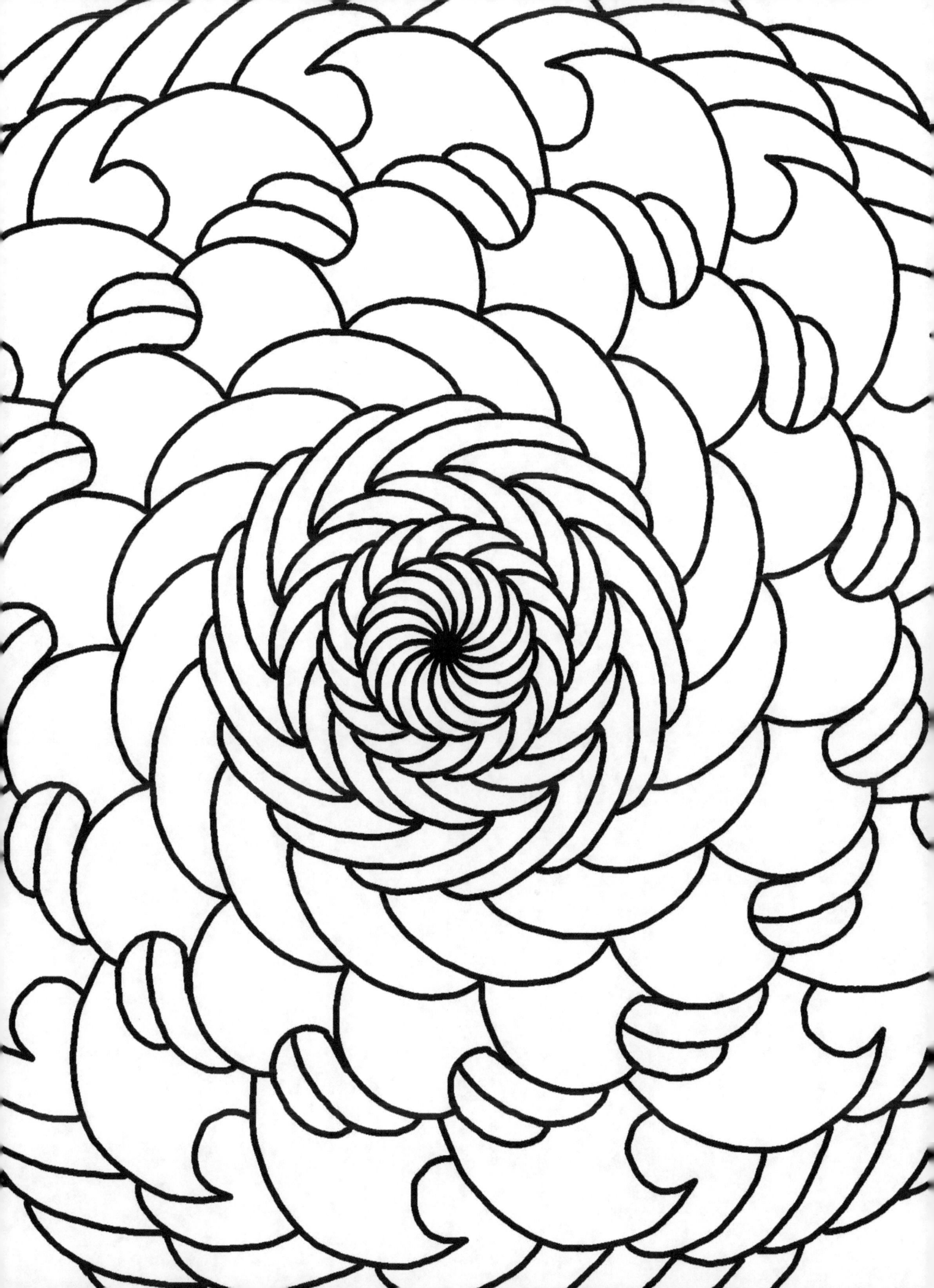

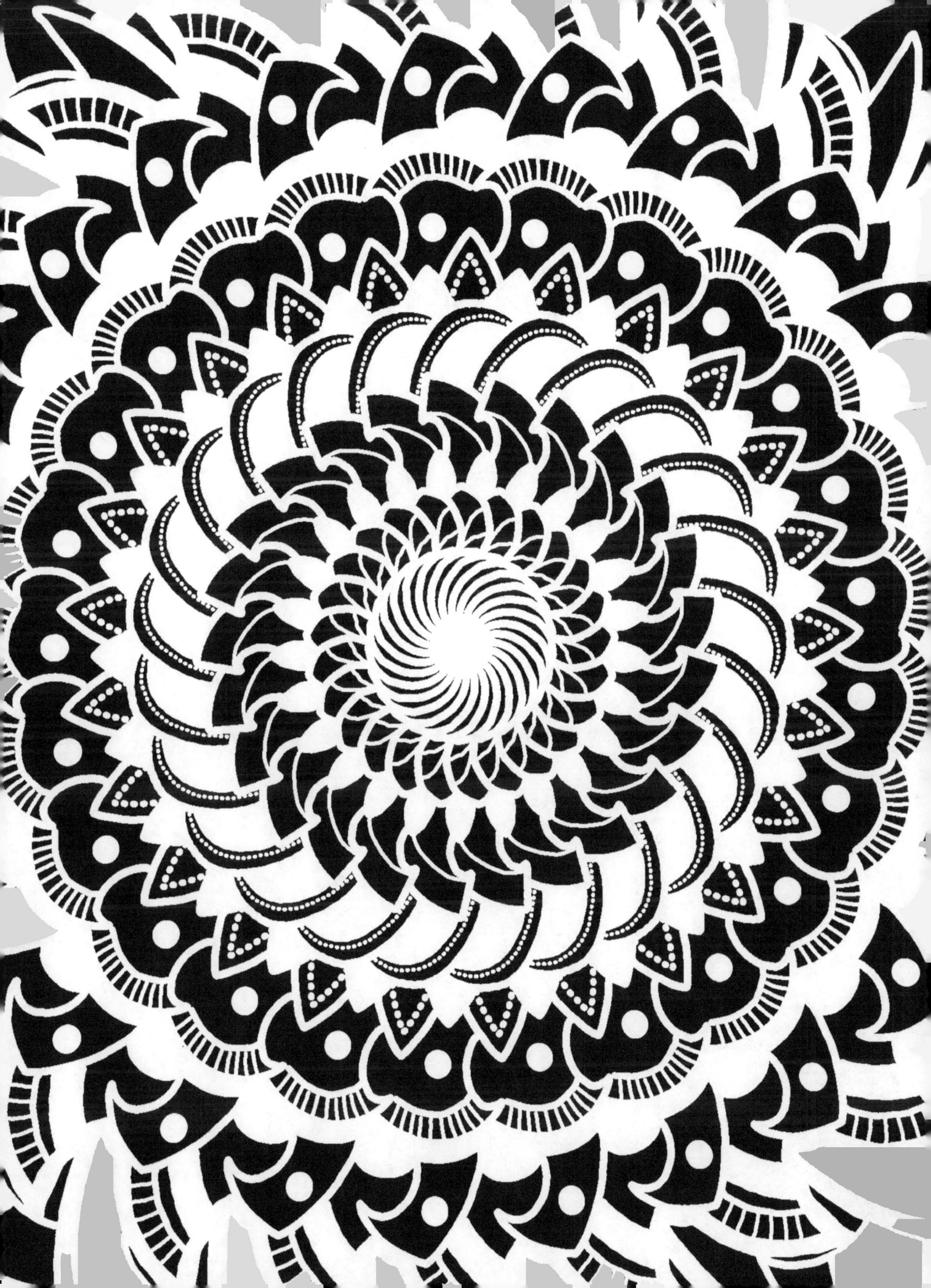

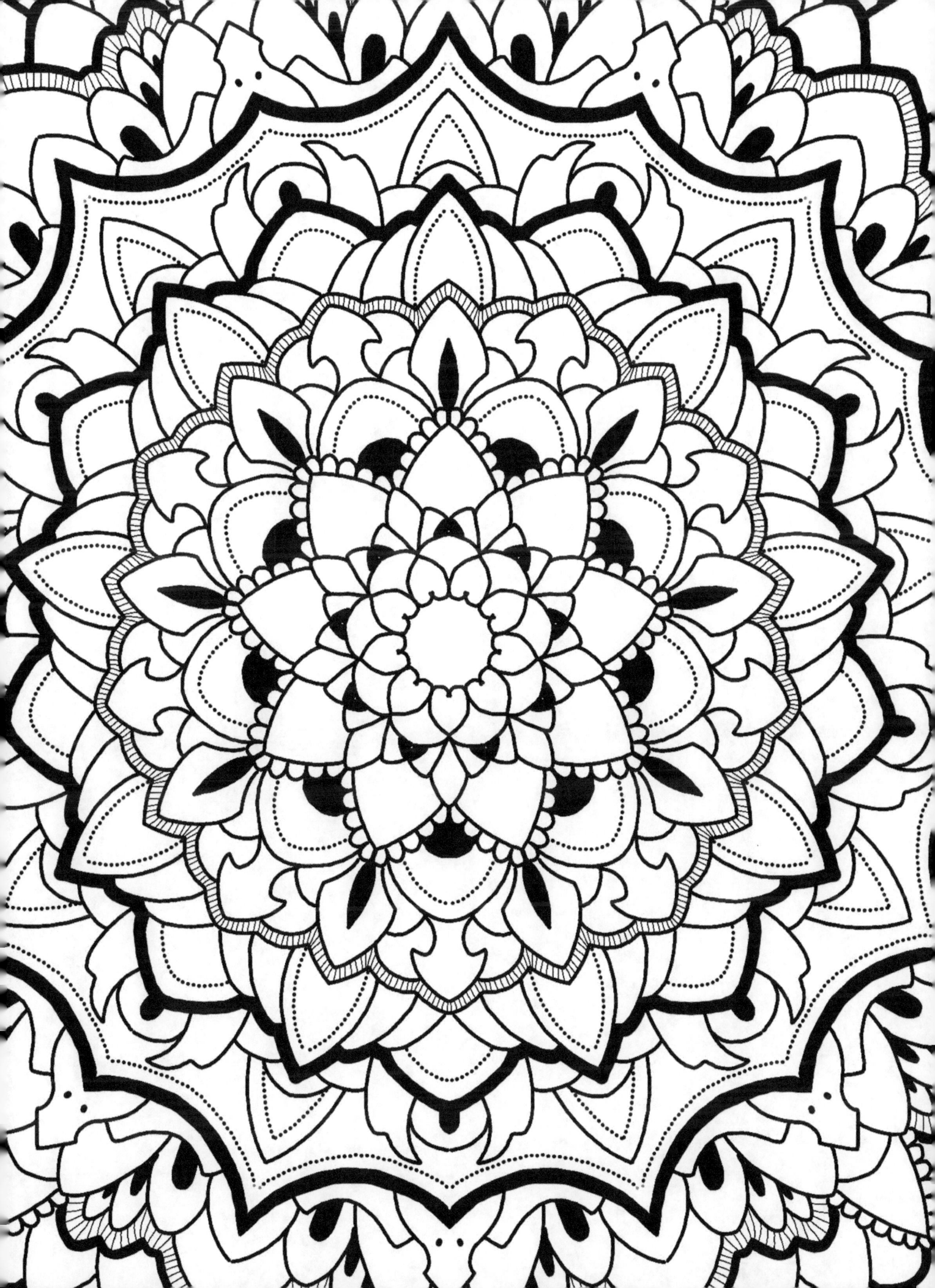

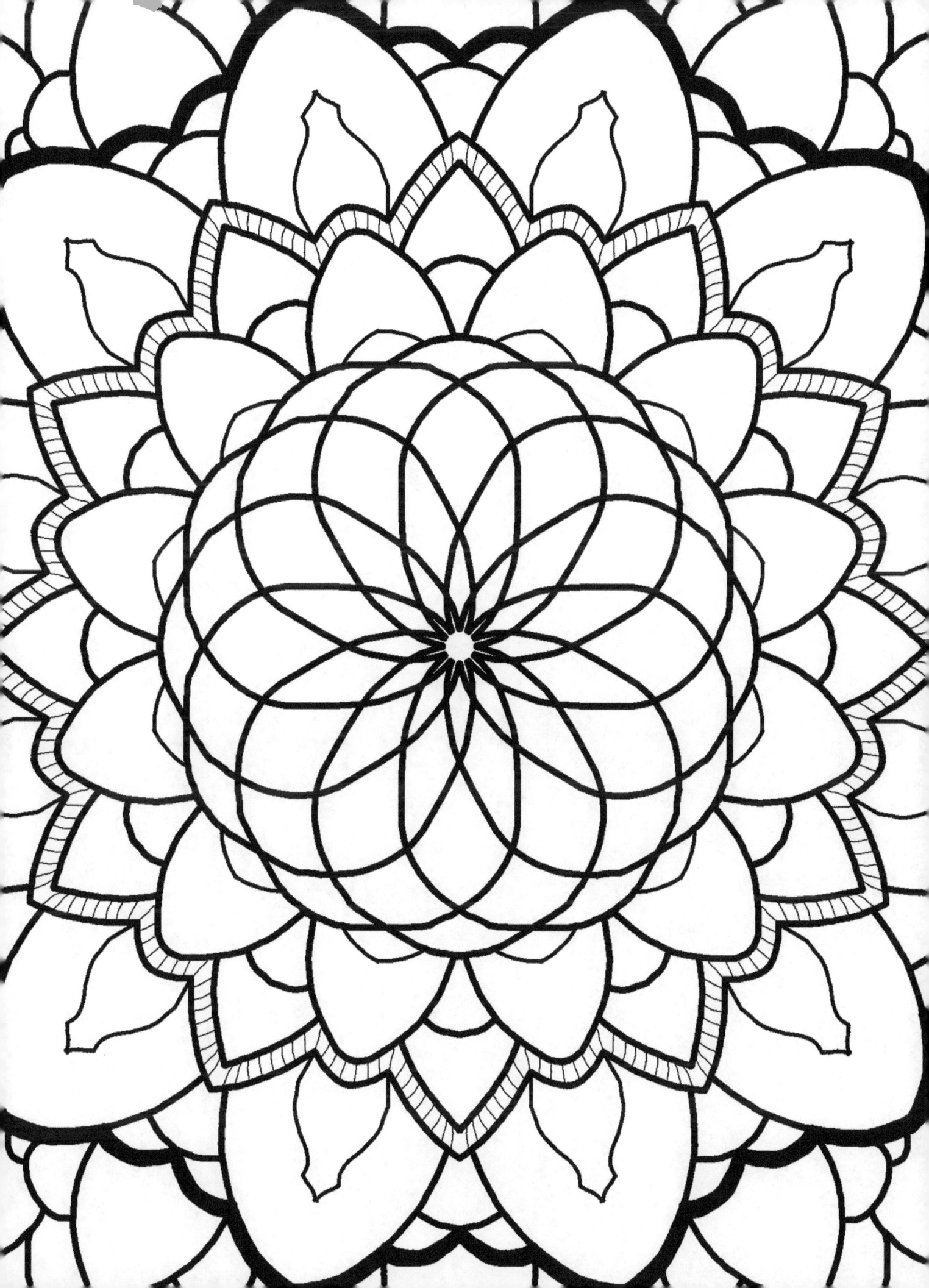

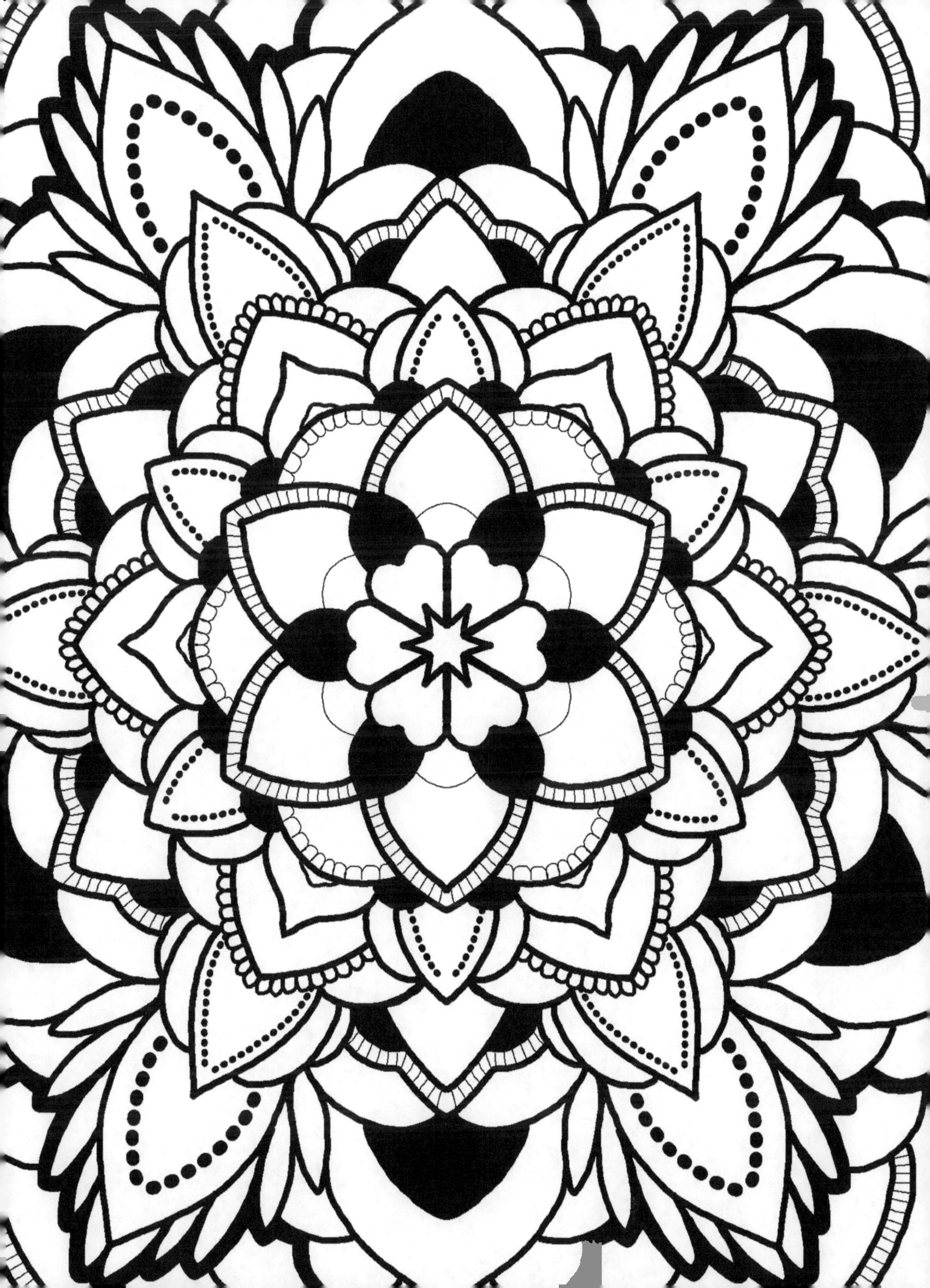

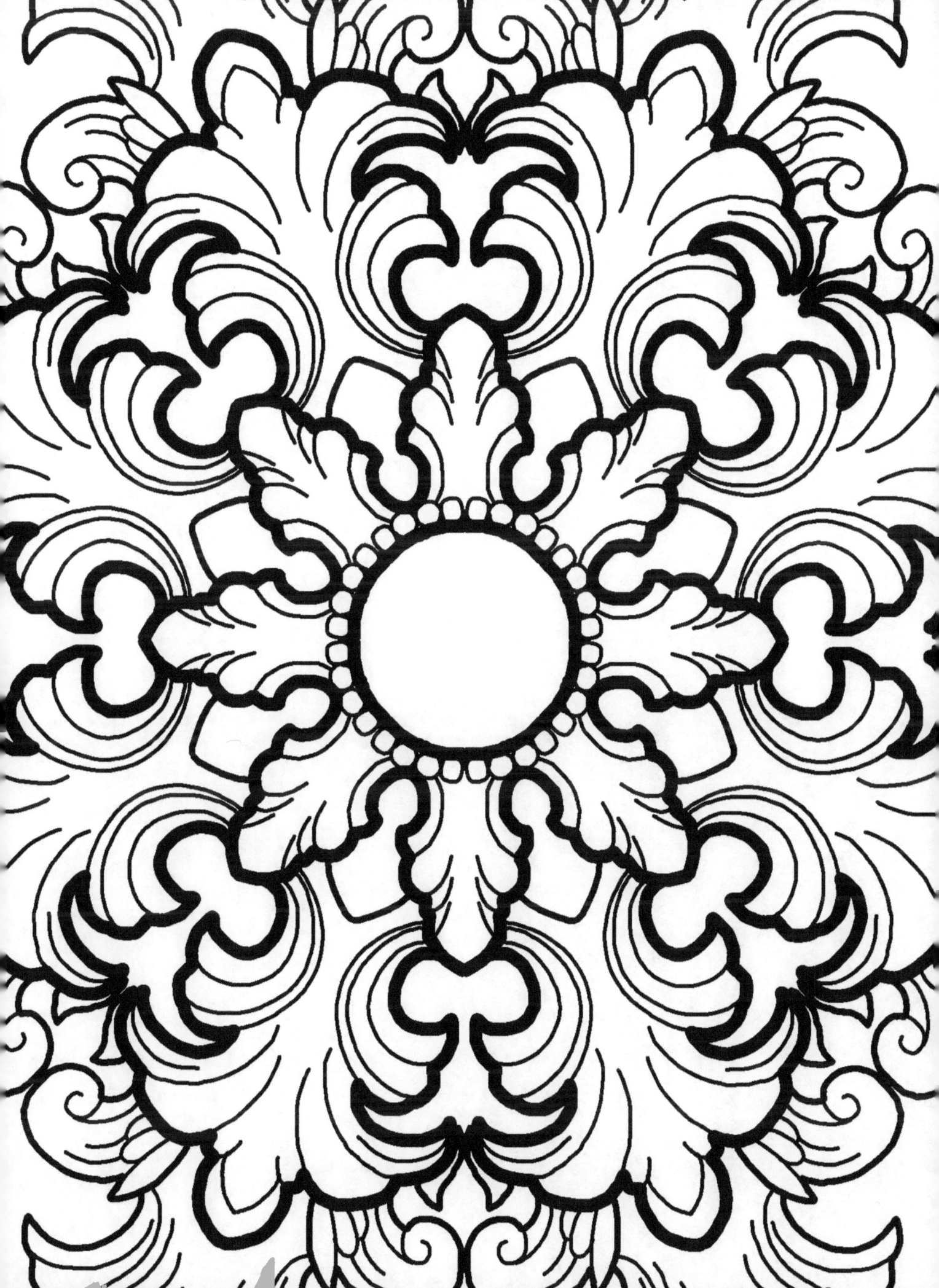

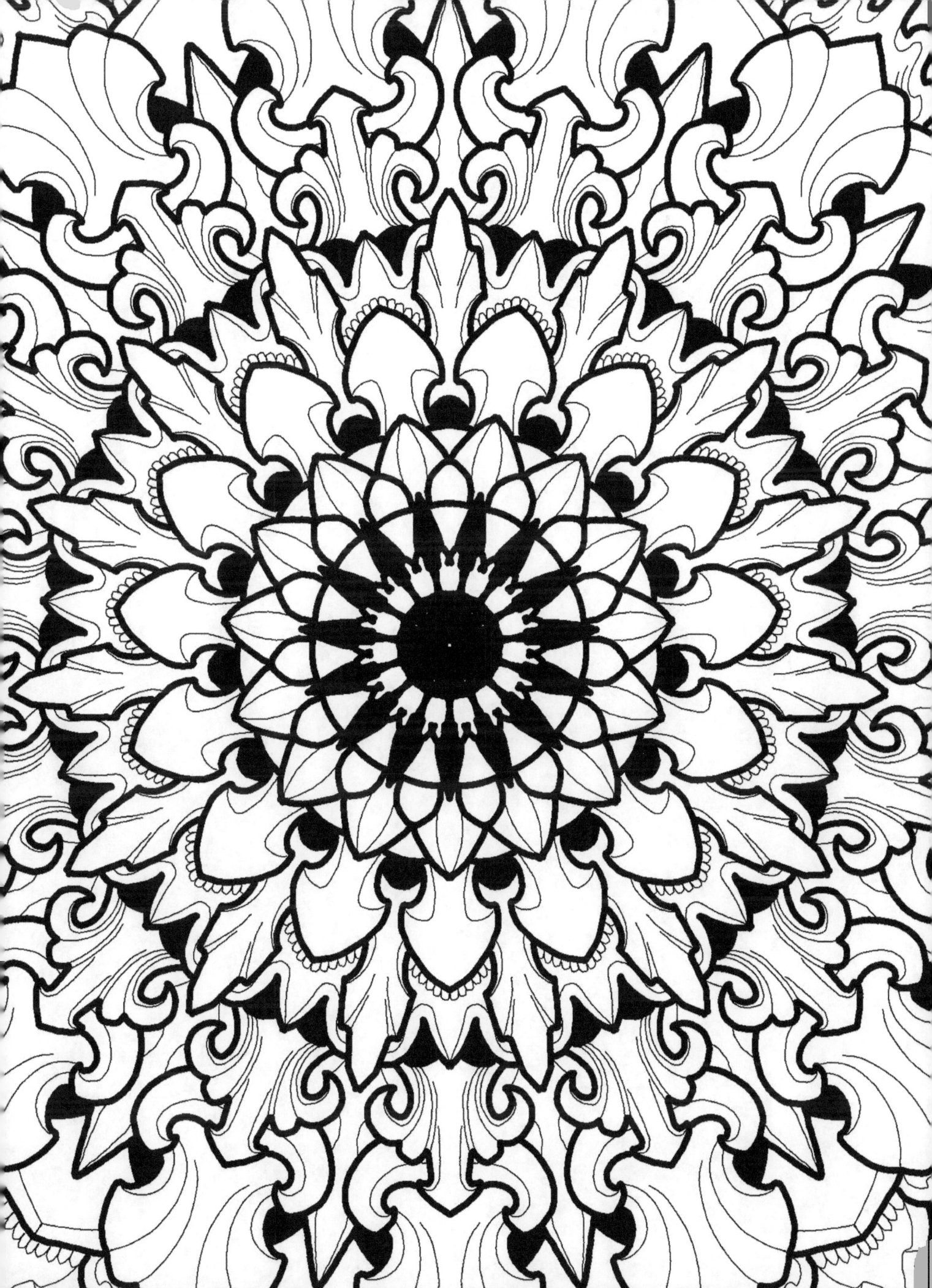

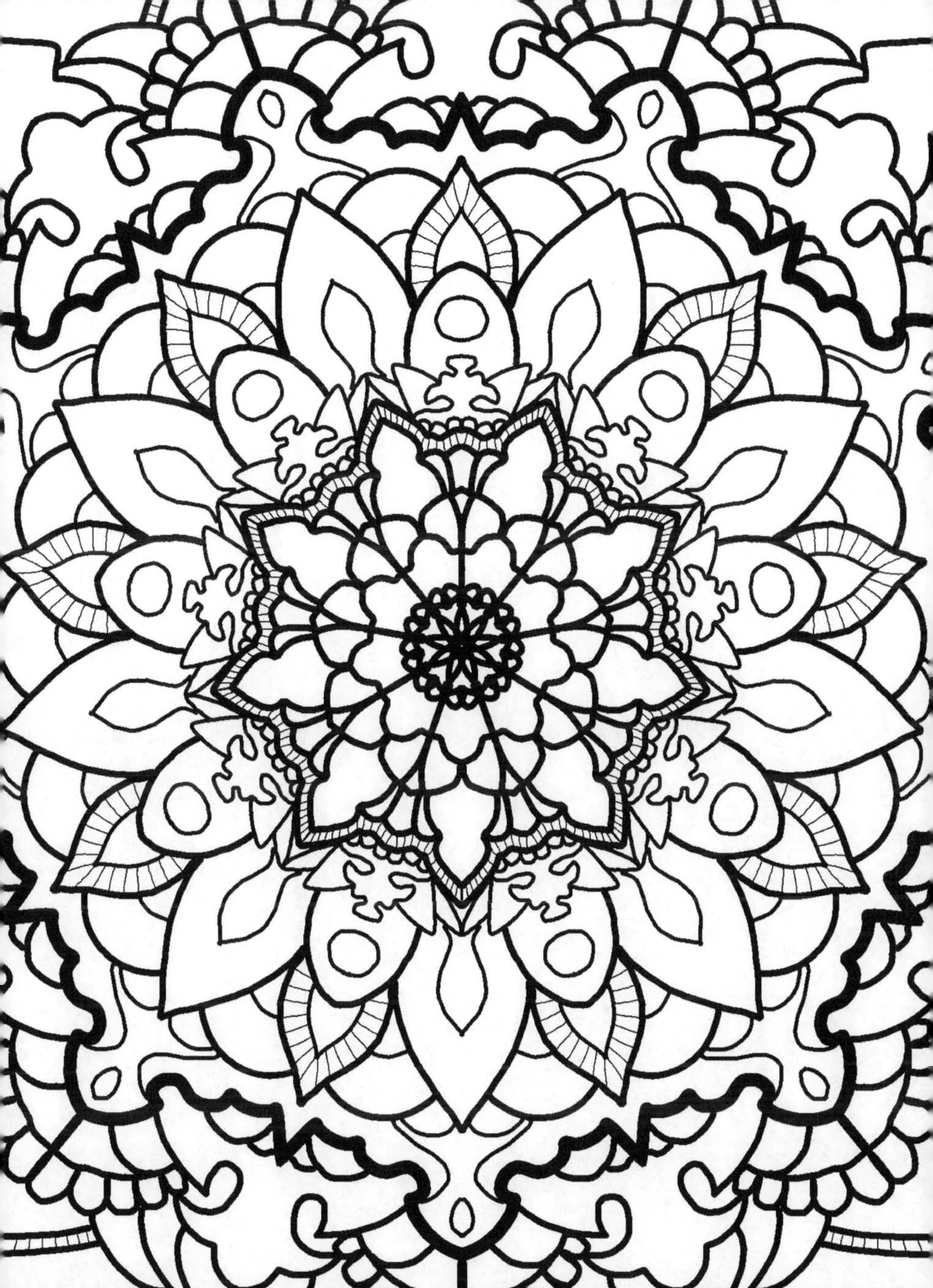

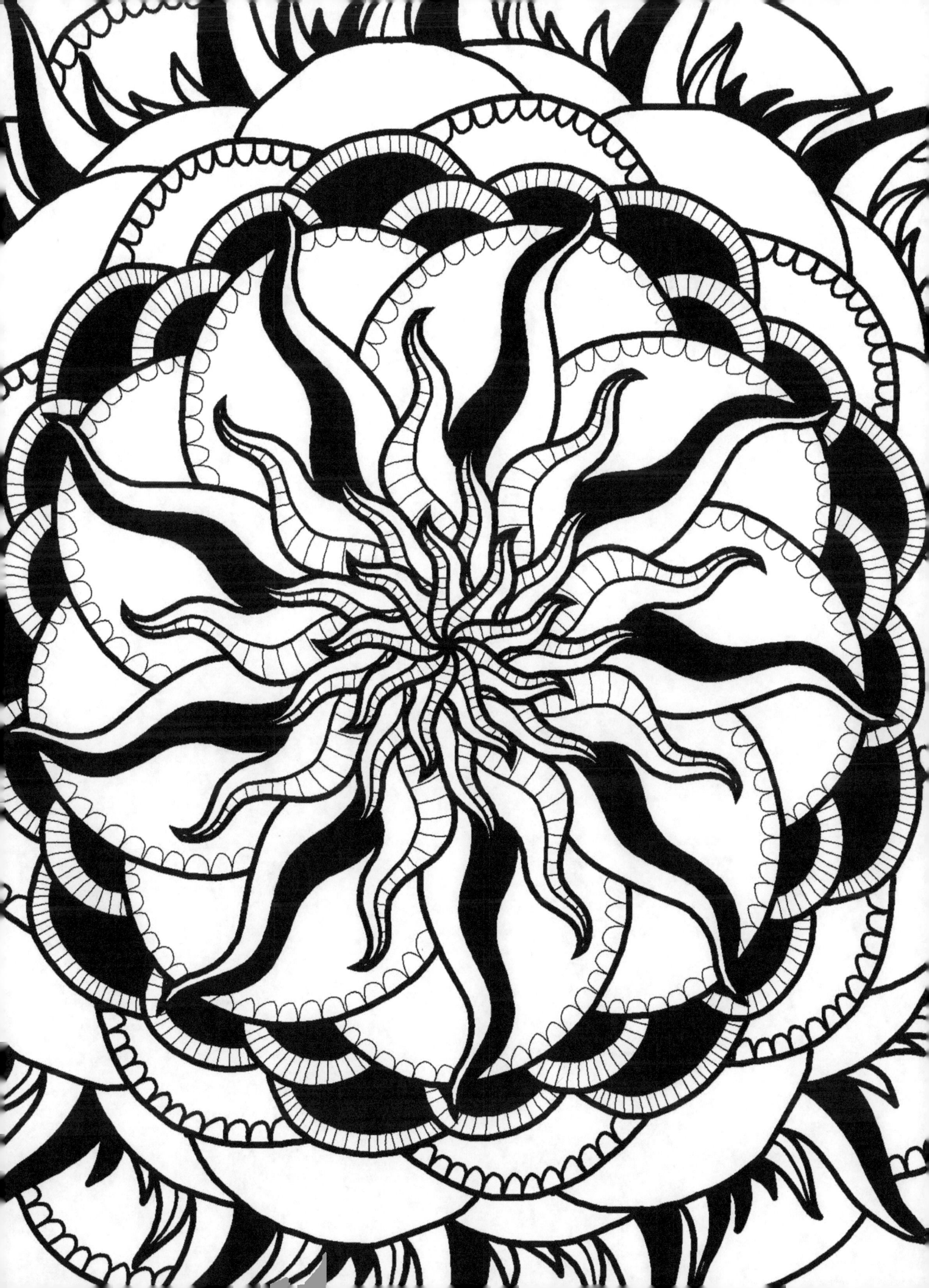

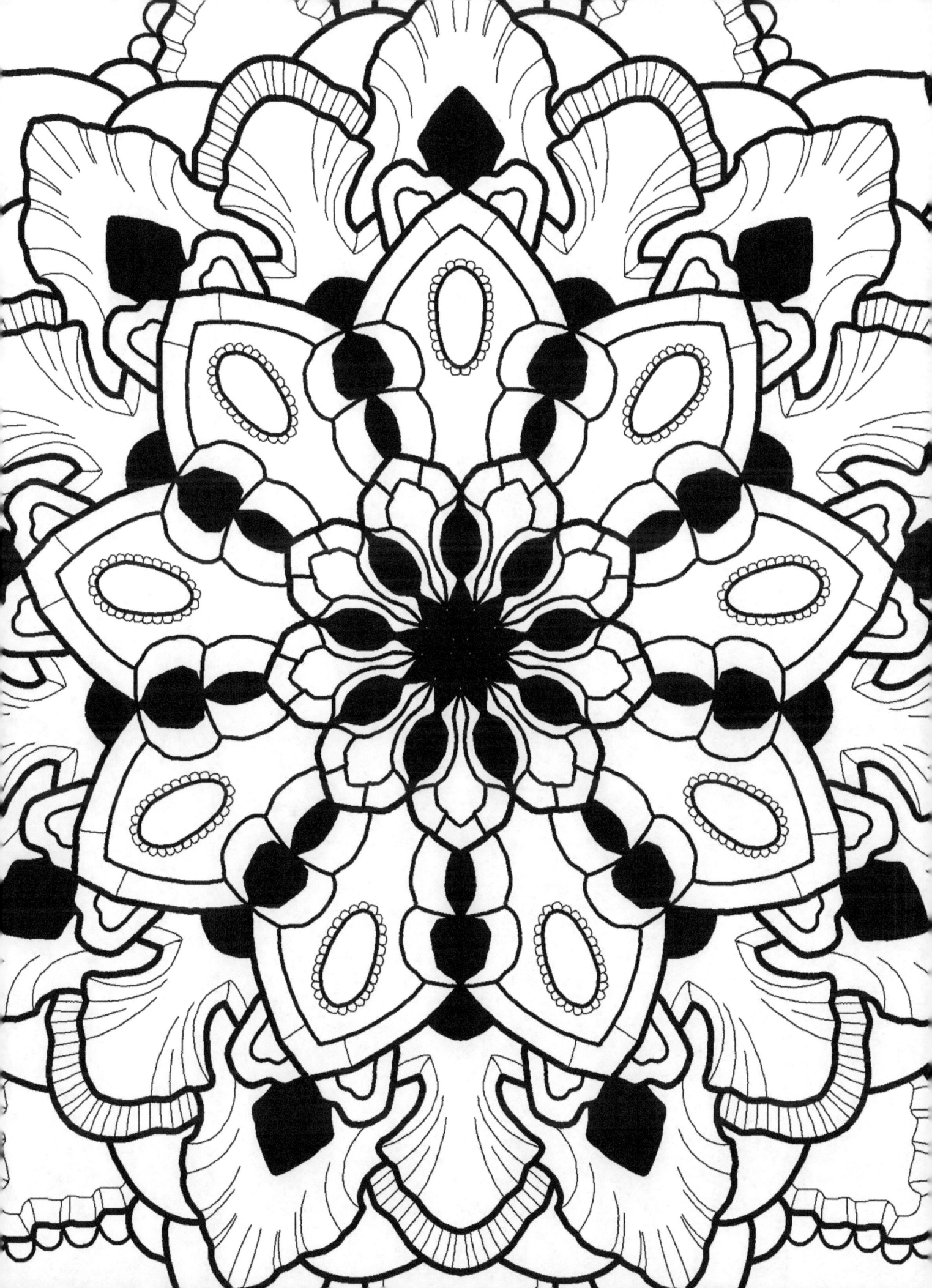

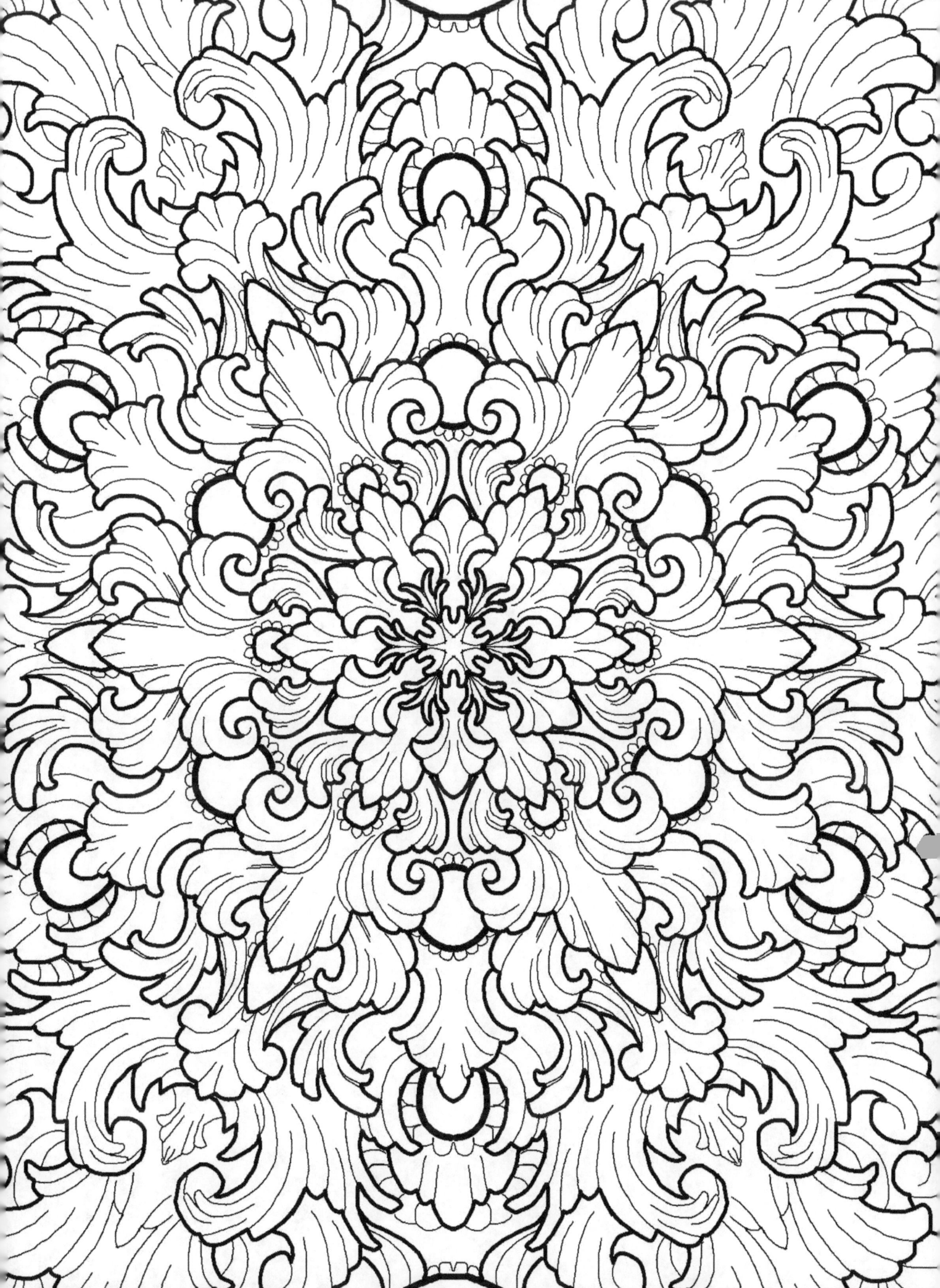

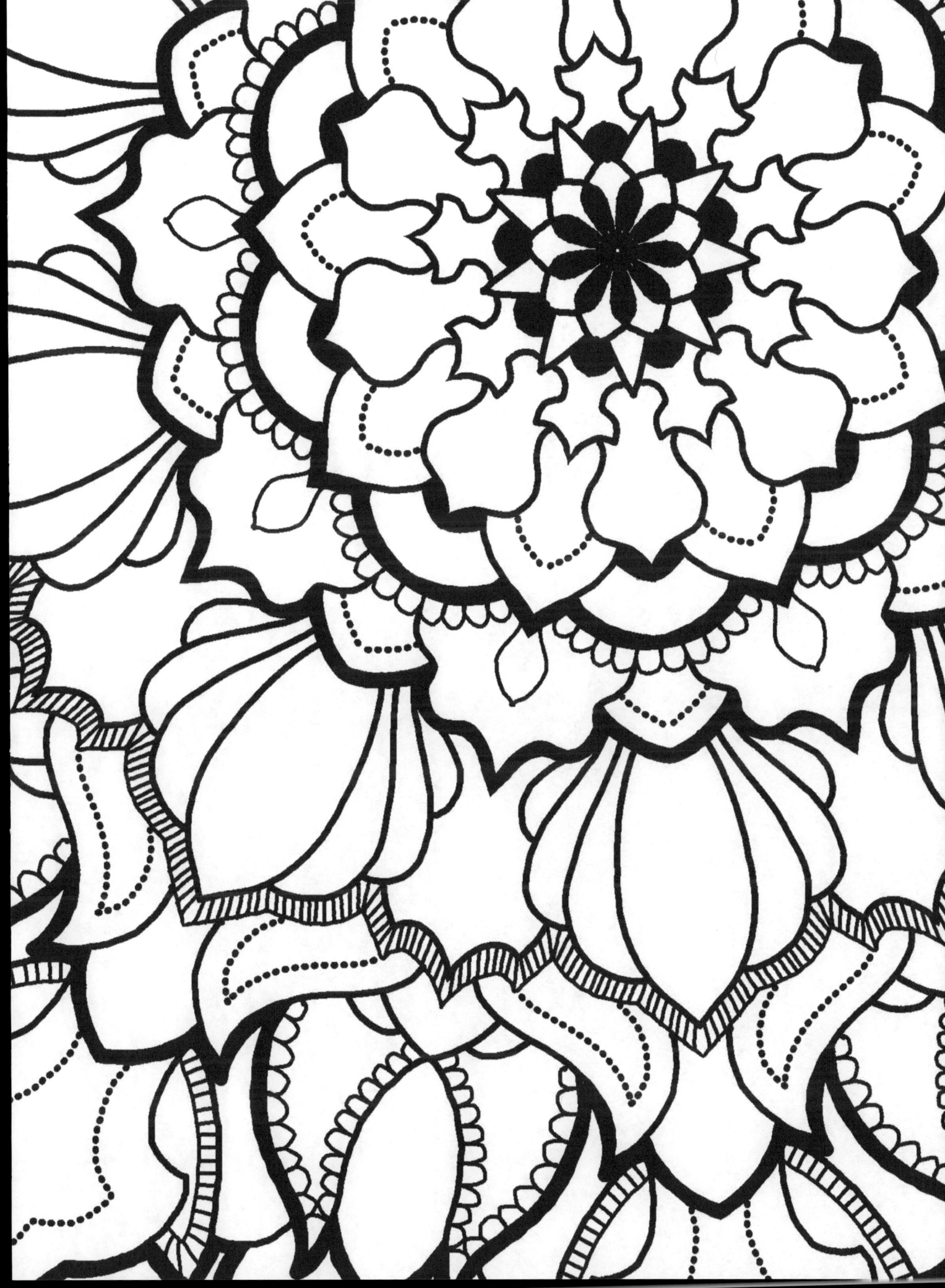

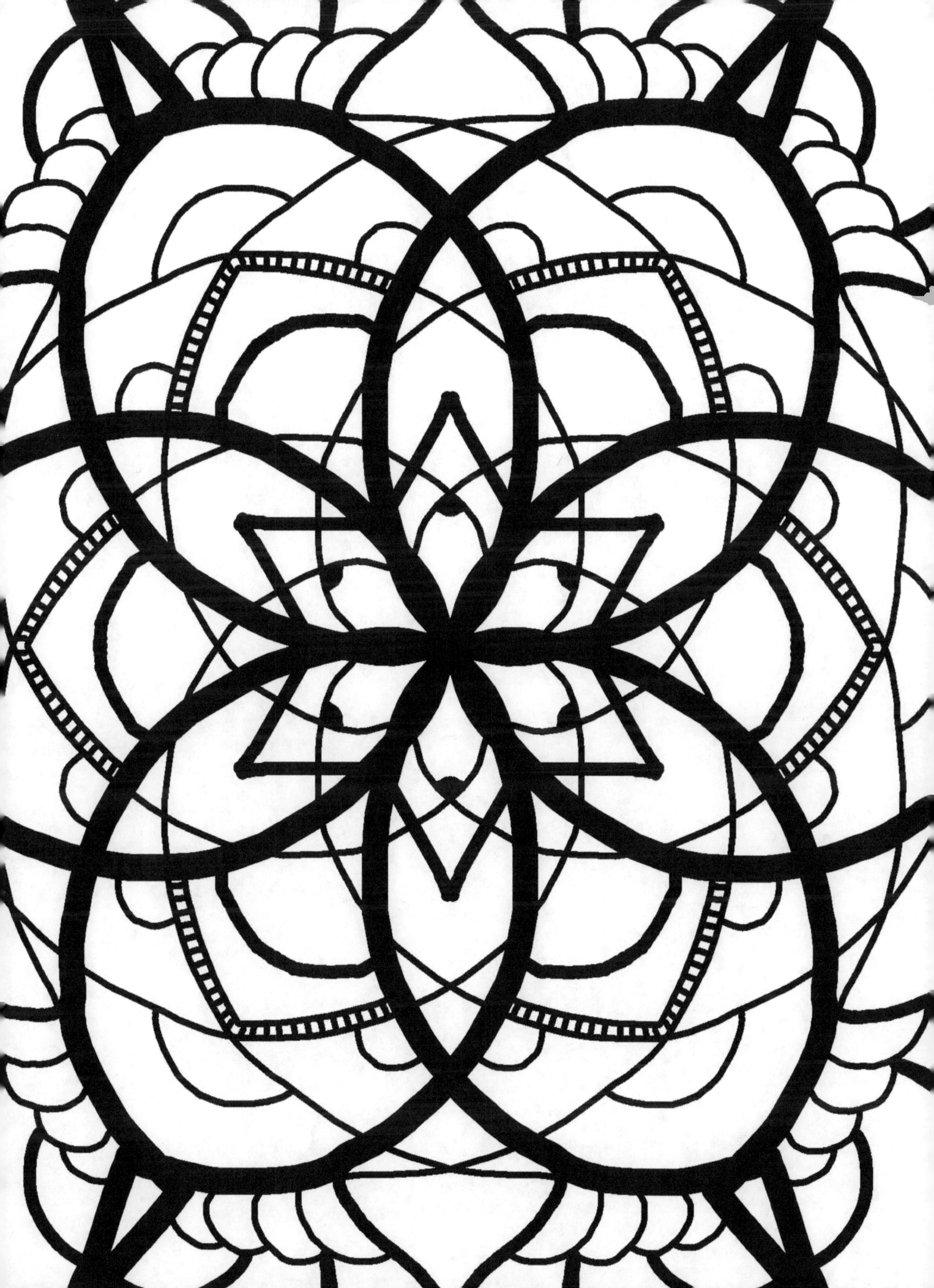

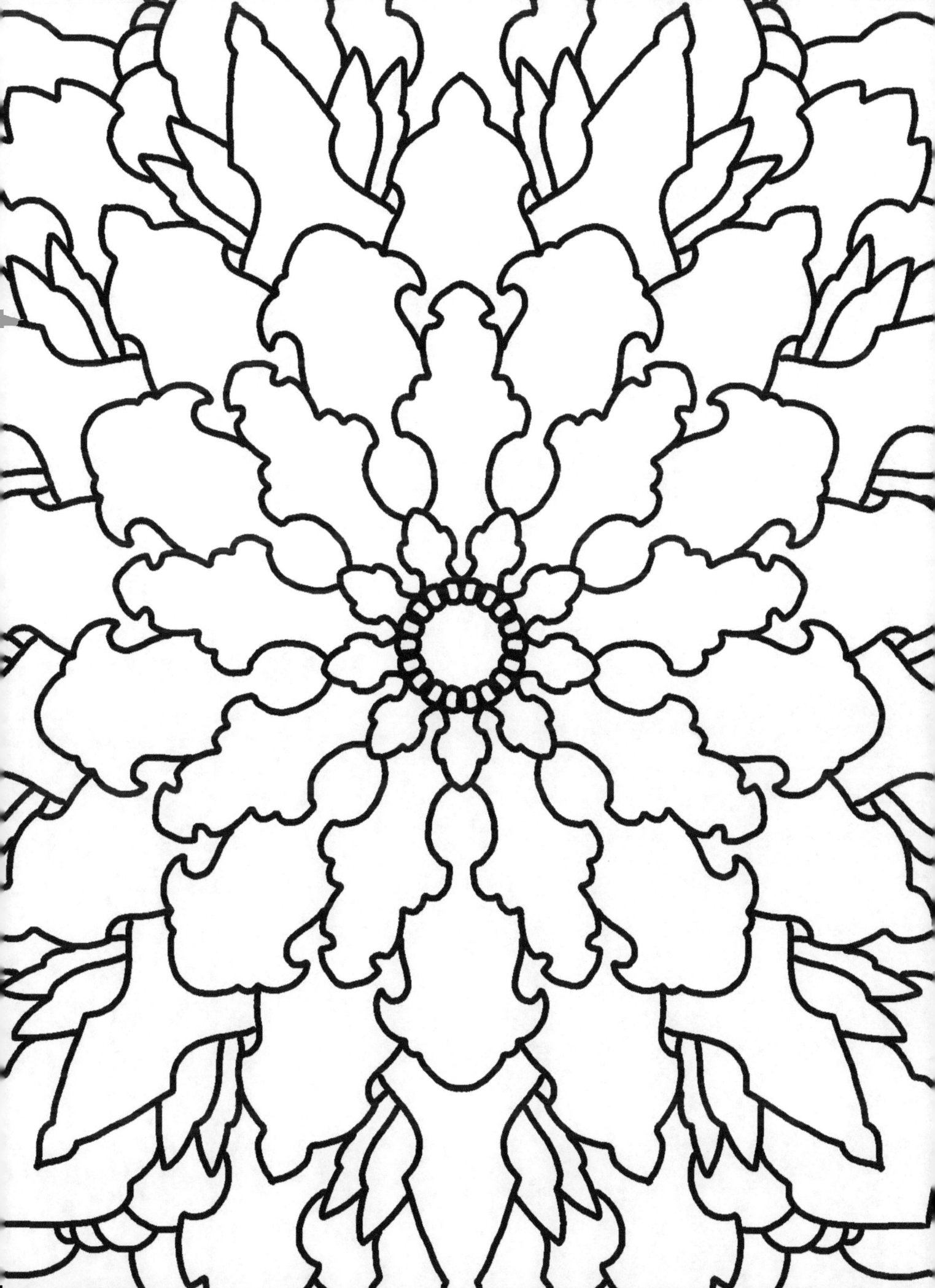

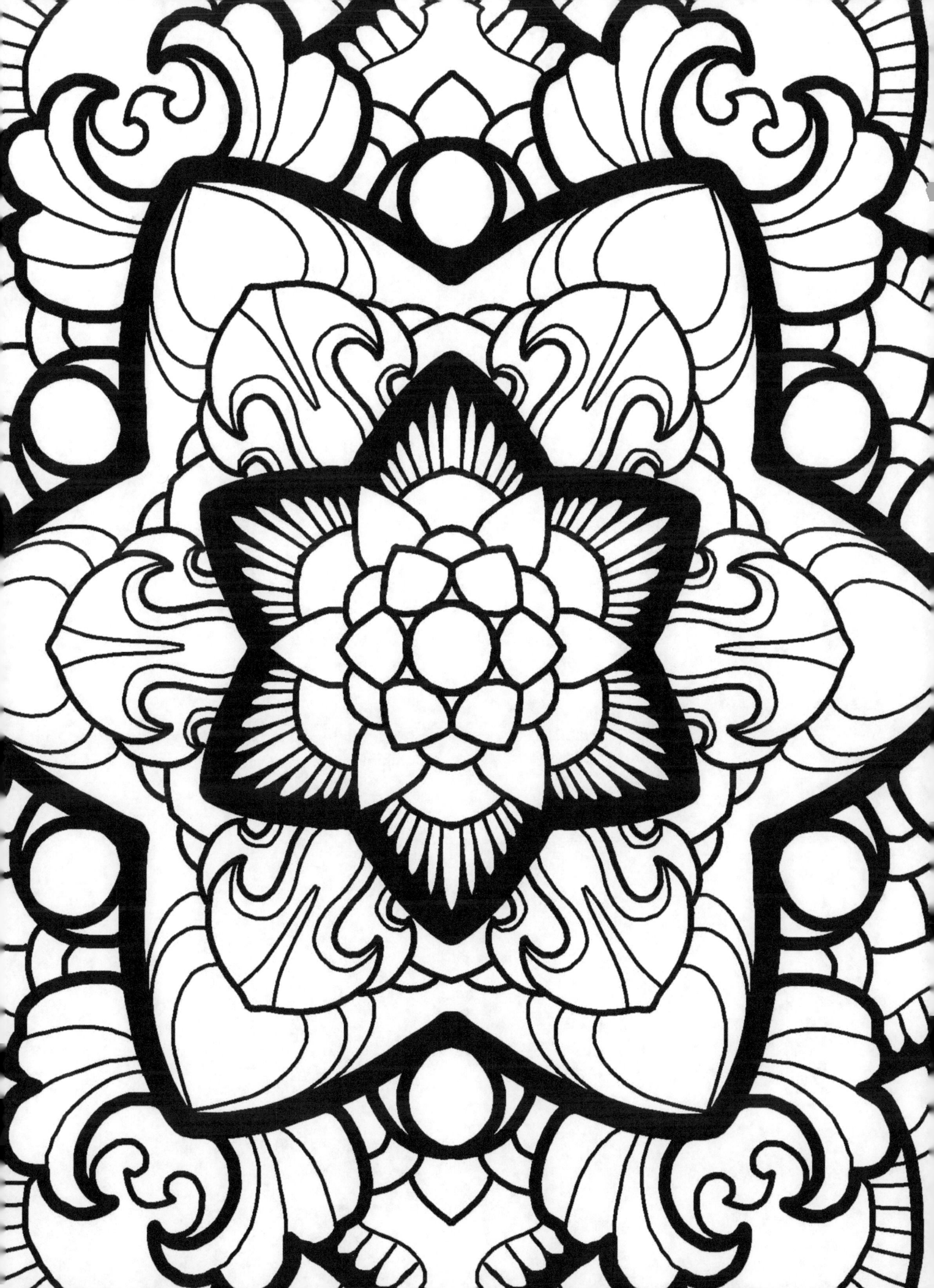

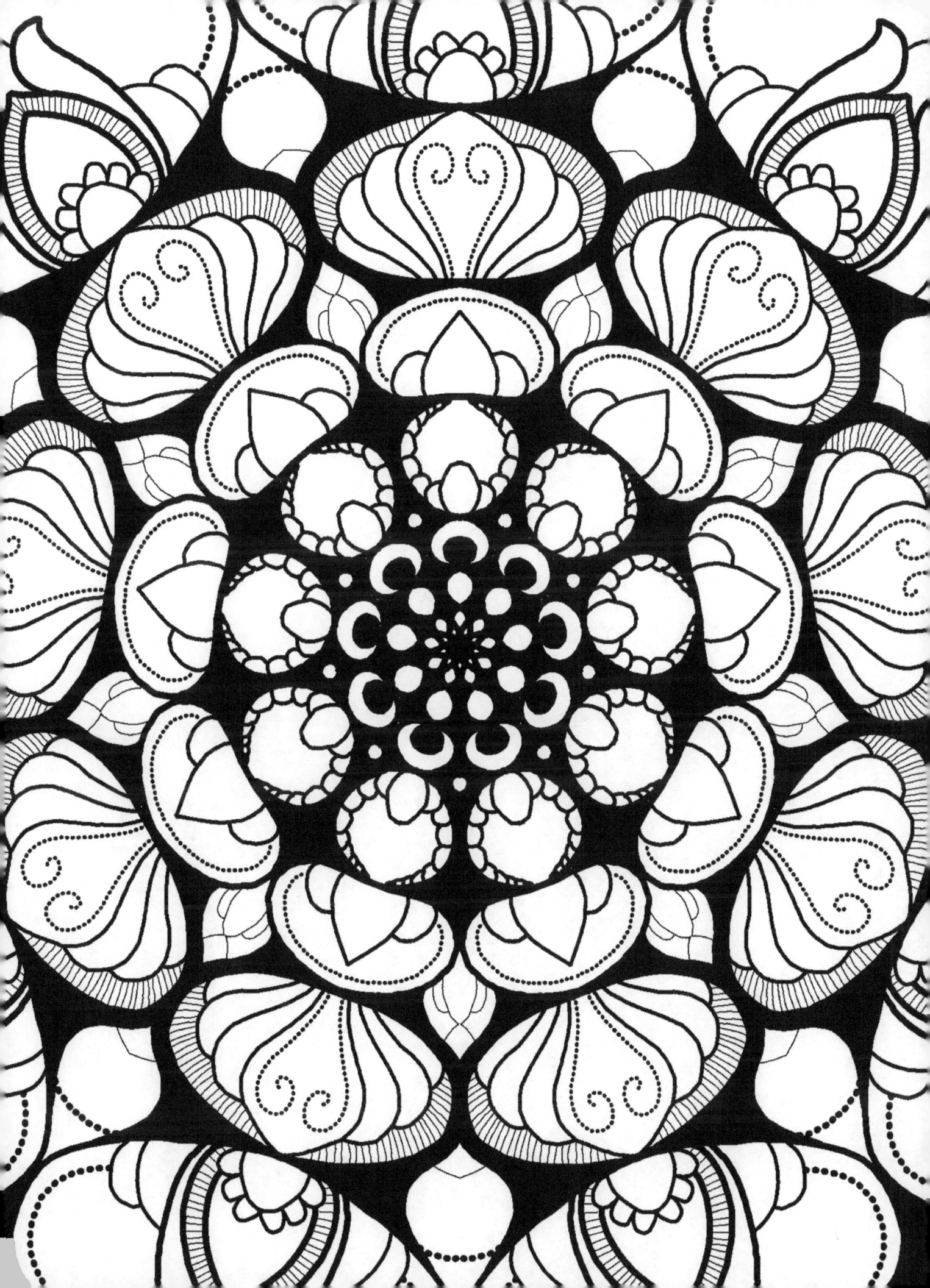

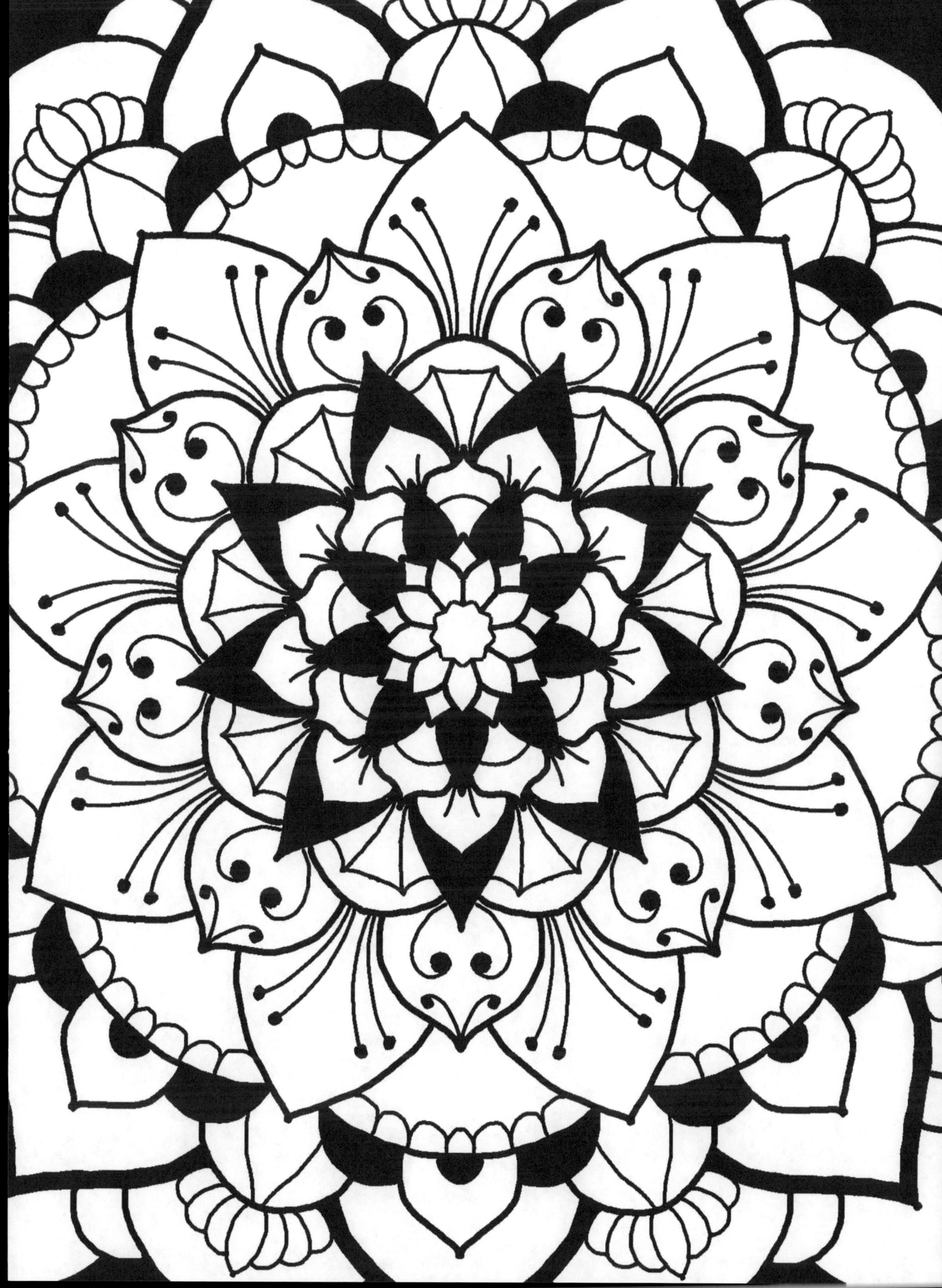

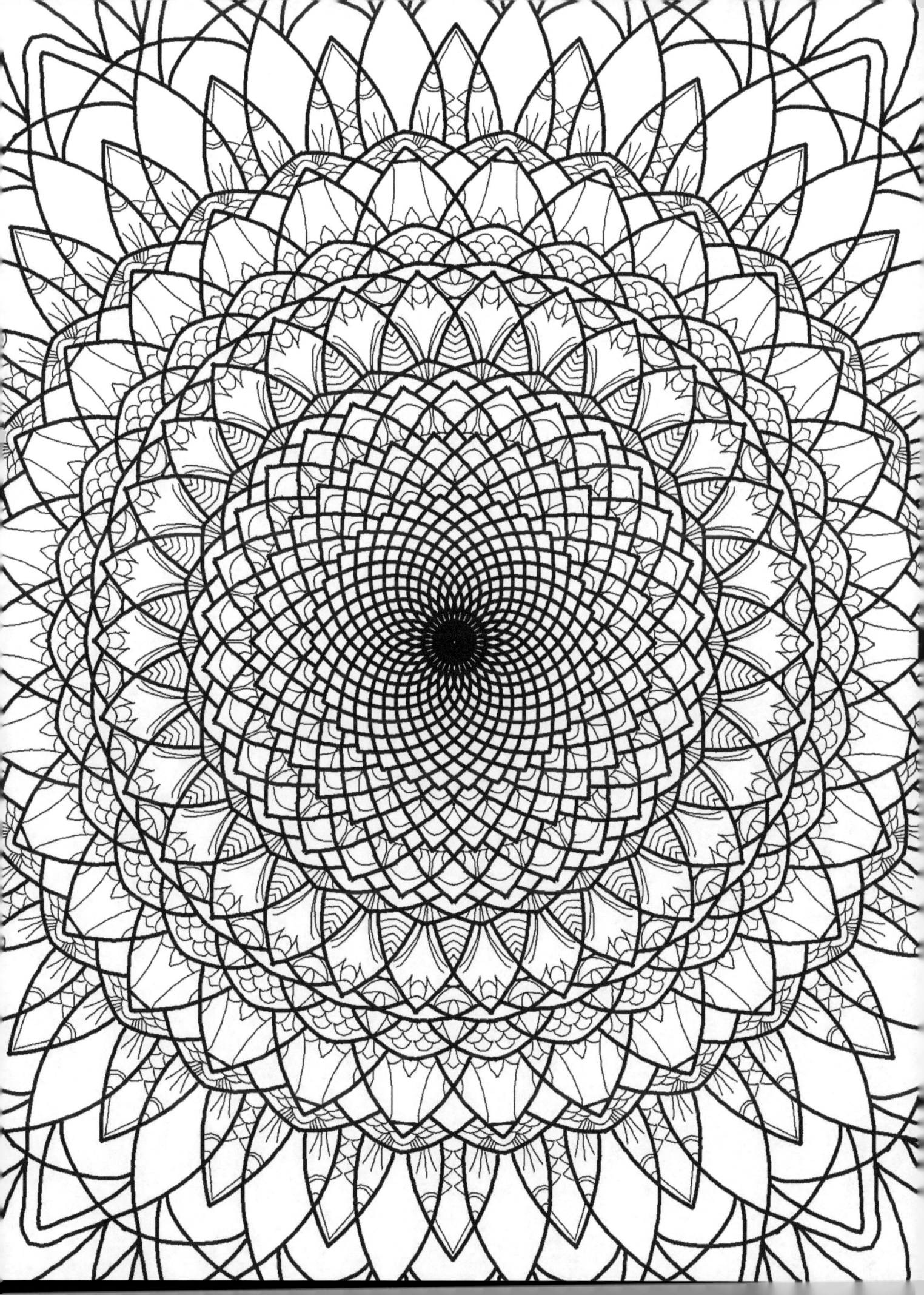

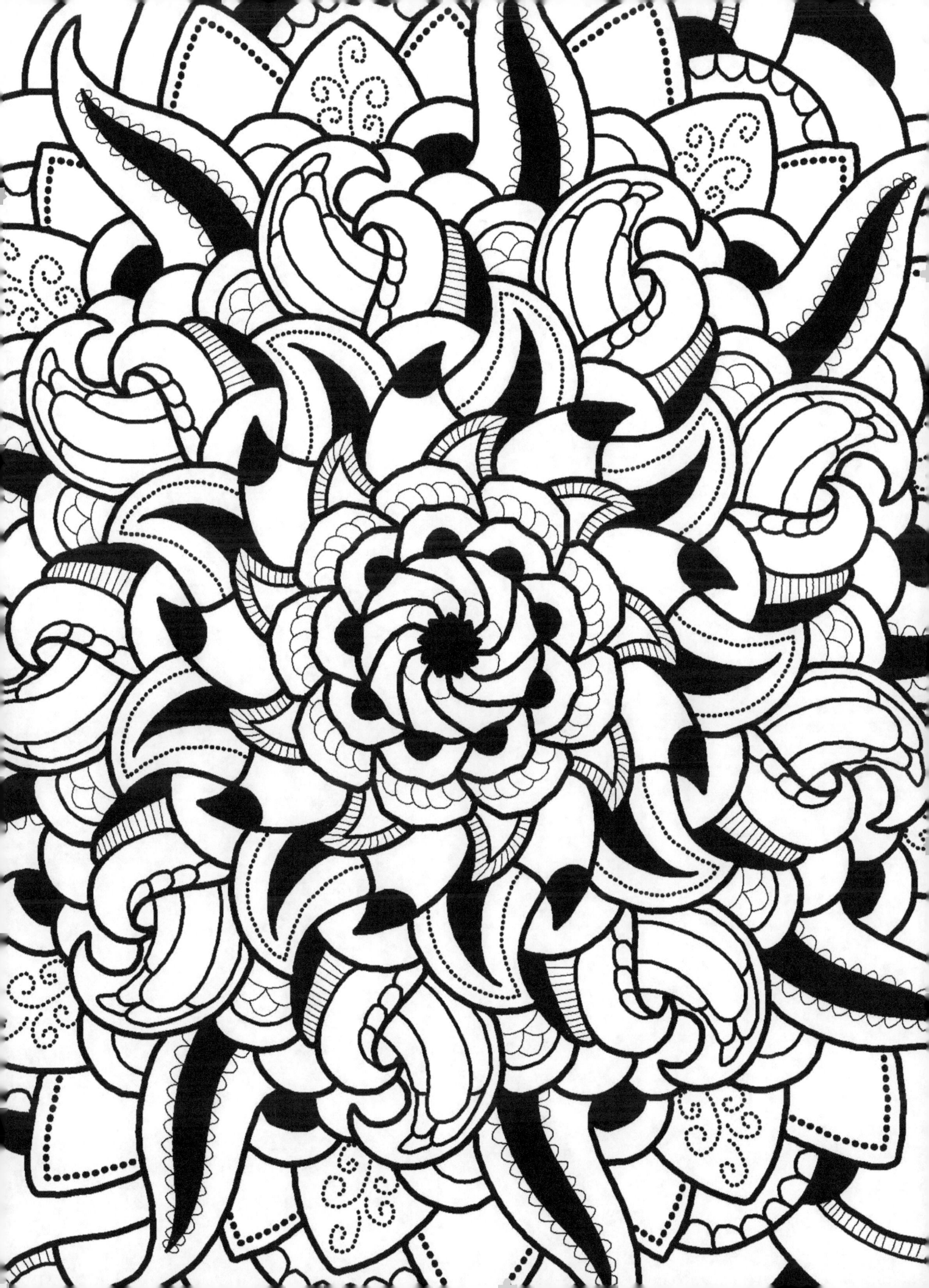

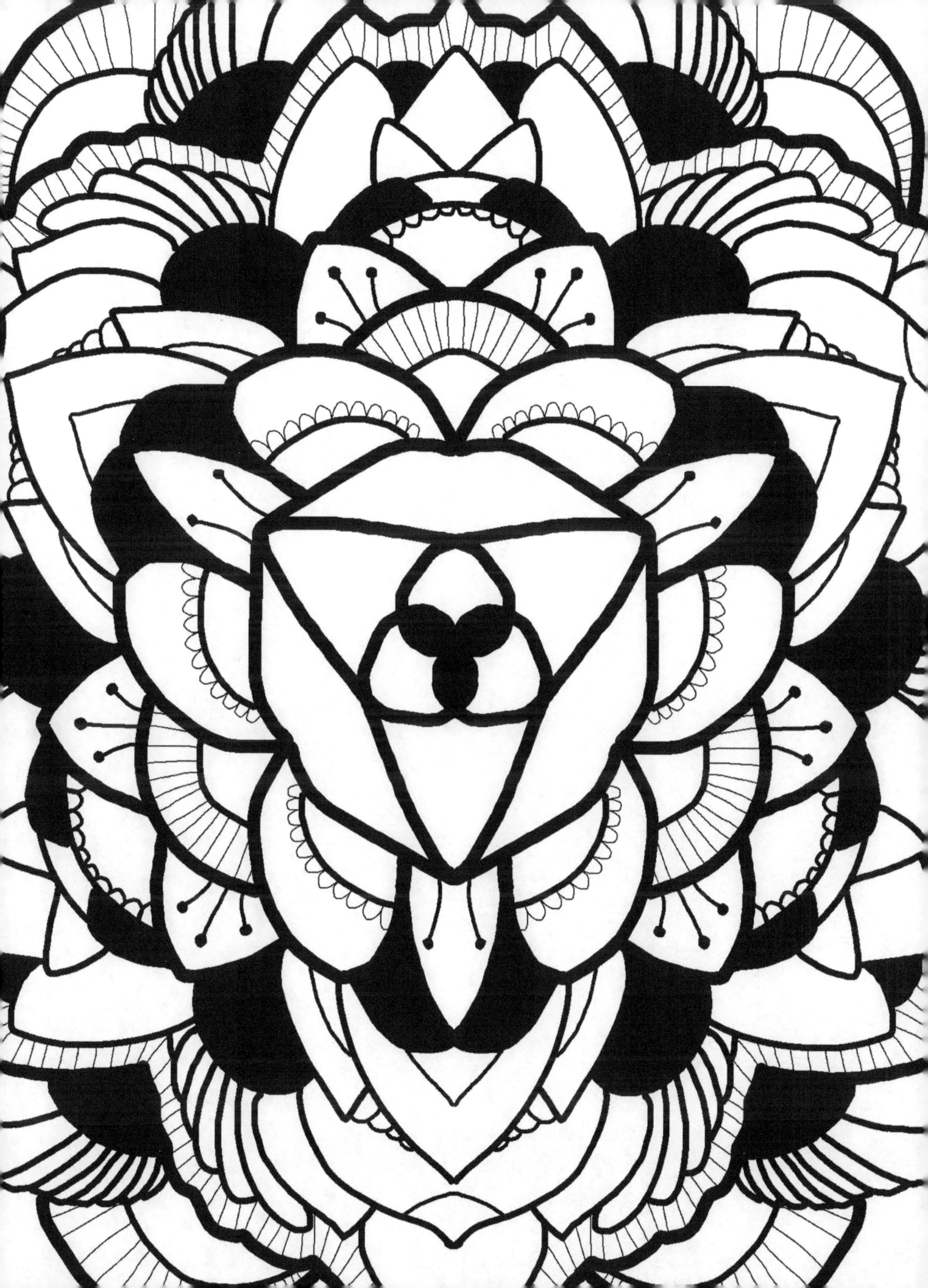

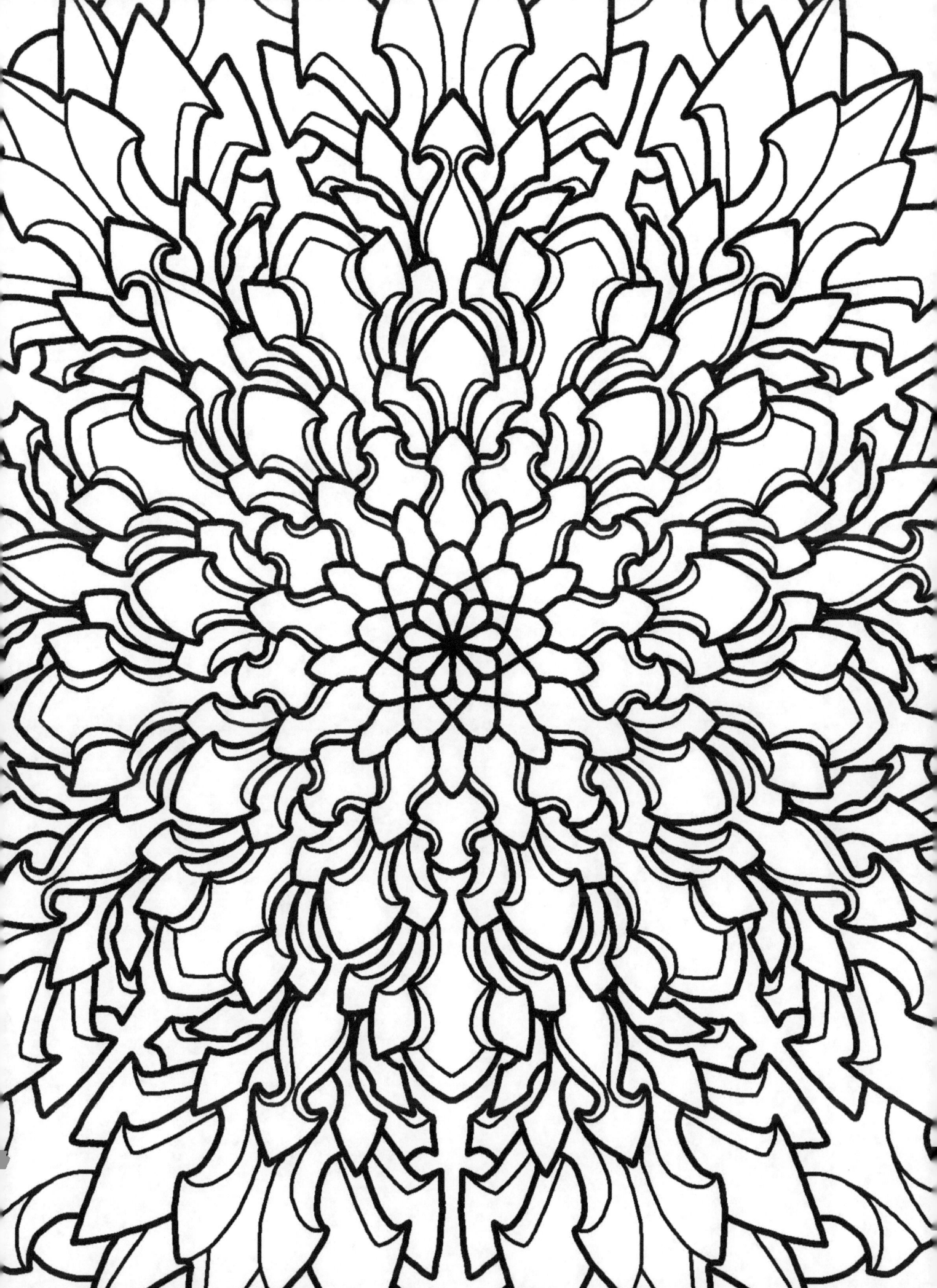

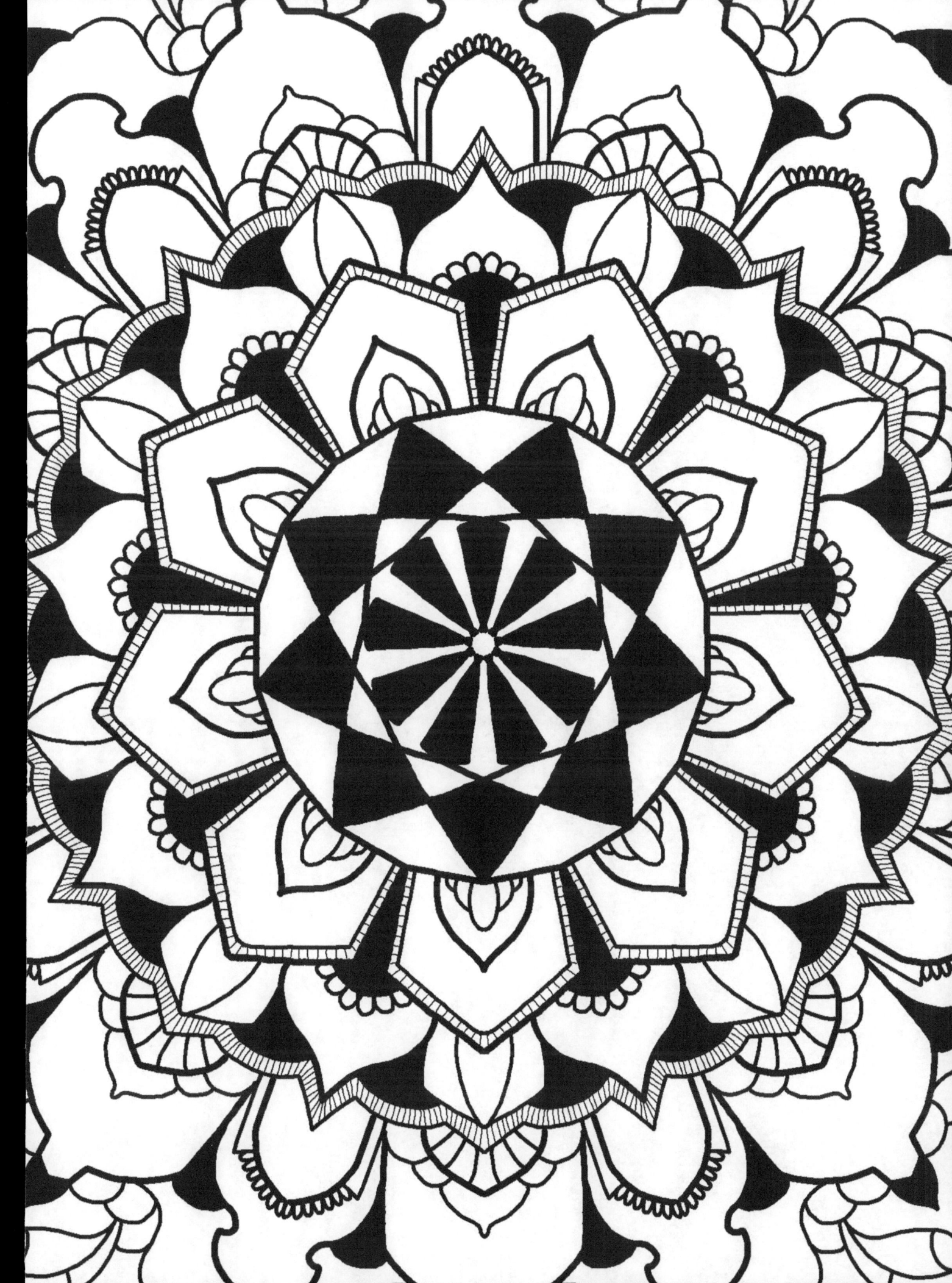

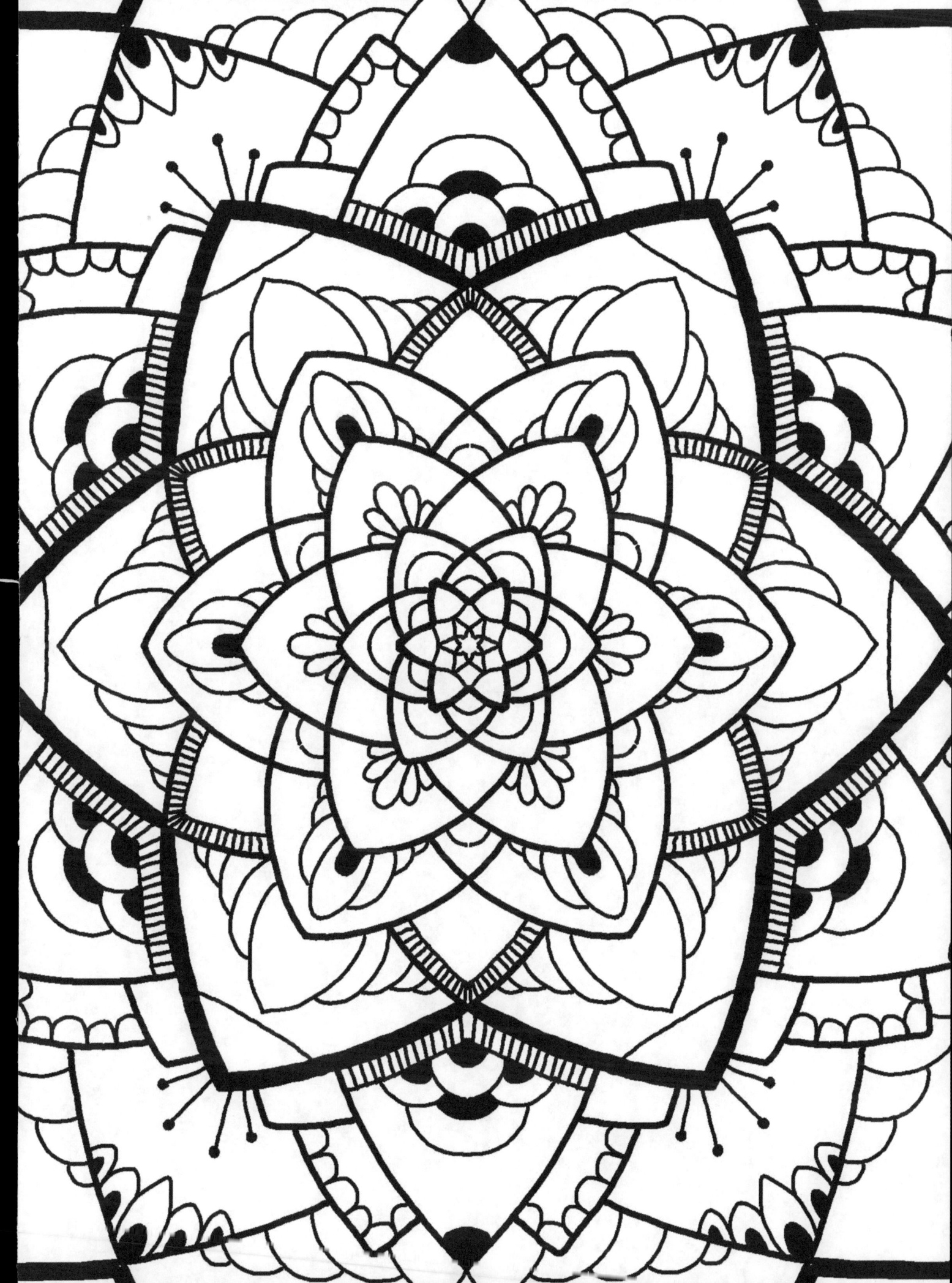

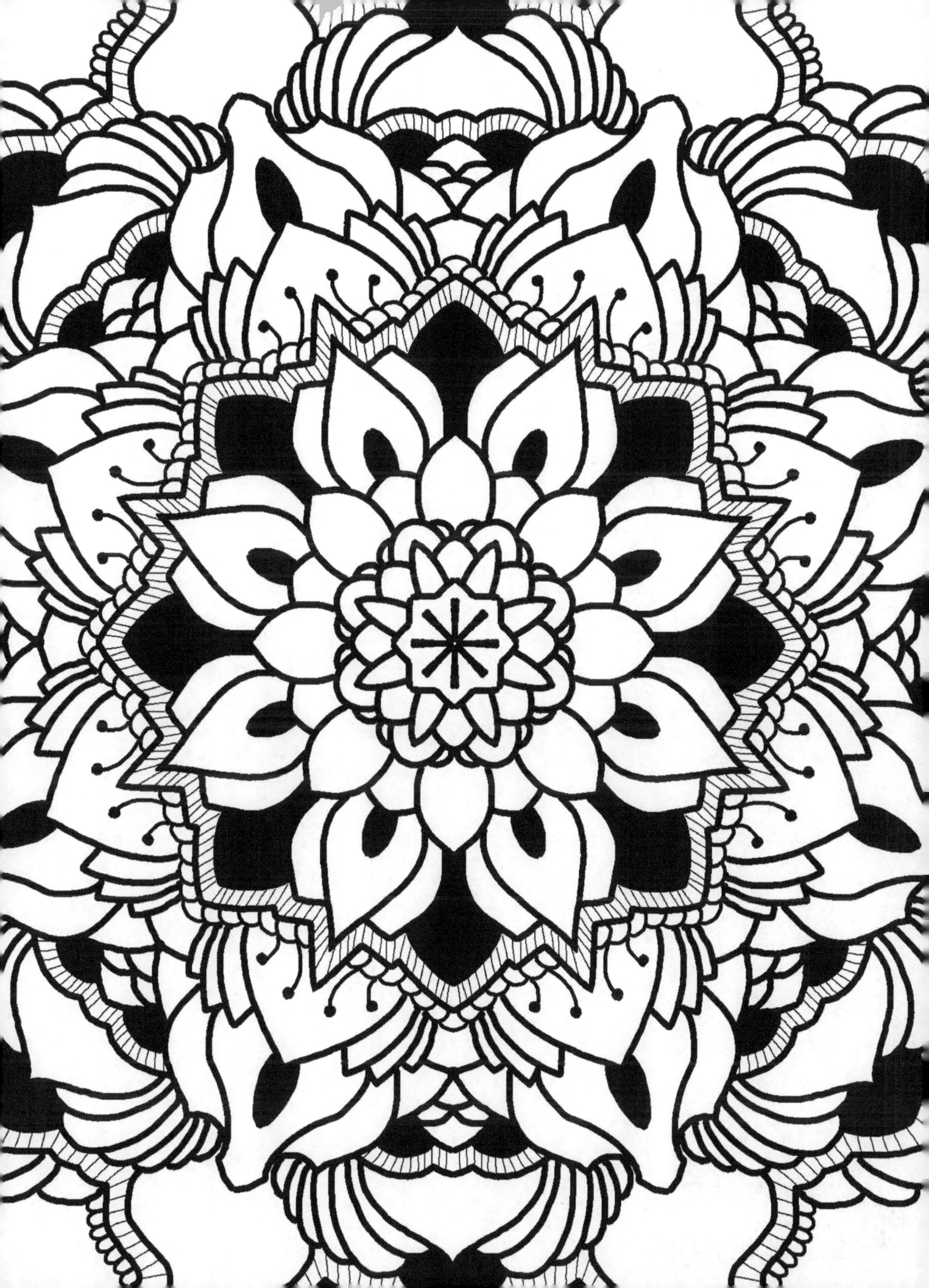

www.ingramcontent.com/pod-product-compliance
Lightning Source LLC
Chambersburg PA
CBHW080707190526
45169CB00006B/2274